399977

ONE WE

D0178107

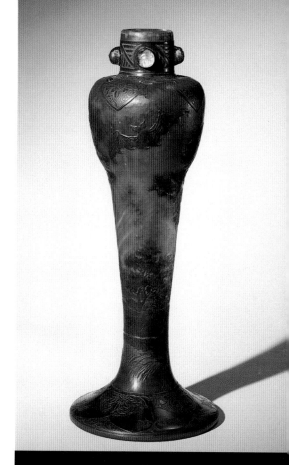

ESSENTIAL ART NOUVEAU

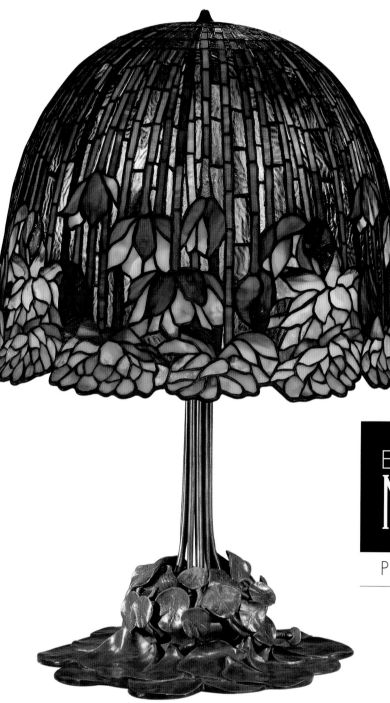

ESSENTIAL ART NOUVEAU

PAUL GREENHALGH

V&A PUBLICATIONS

For Jack and Alex Greenhalgh

First published by V&A Publications, 2000

V&A Publications
160 Brompton Road
London SW3 1HW

Designed by Janet James

ISBN 1851772960

A catalogue record for this book is available from the British Library.

Printed in Italy

Jacket illustrations:

FRONT: Victor Horta: first floor, Tassel House. Brussels, 1893. Tiffany: glass flask. American, 1896.
BACK: Aubrey Beardsley: detail from *The Black Cape*. English, 1894.
TITLE PAGE: Tiffany: 'water-lily' table lamp. American, 1904-15. Metropolitan Museum of Art.
INTRODUCTION: Tiffany: vase. American, 1893-96. Metropolitan Museum of Art, New York.

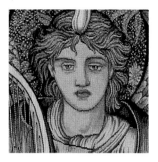

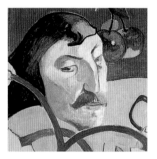

CONTENTS

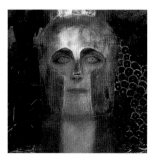

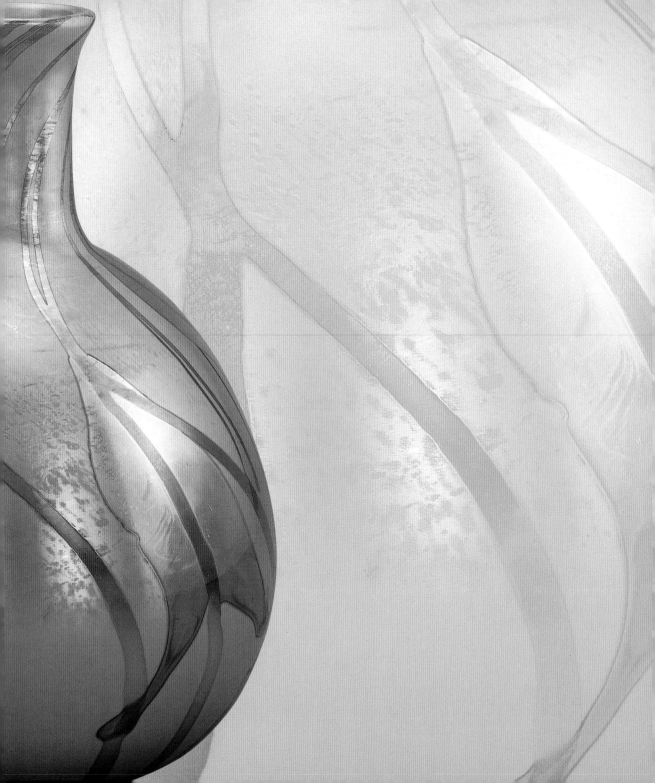

INTRODUCTION

Imagine a world in which virtually every aspect of life has undergone, in a single life-span, a complete physical transformation. Imagine a situation in which virtually everything you have come to expect as the normal way of doing things, the places you live in, the clothes you wear, the food you eat, the types of people you generally meet, the god you worship and the pace at which things happen, begins to change. Imagine how you would feel as it began to dawn on you that the way you lived your life had become completely different from the way your parents lived theirs, and absolutely unrecognizable from the existence of your grandparents. Imagine the apprehension you might feel at the thought that these changes to your world were not a temporary phenomenon, but were permanent, and that this permanent change was not to do with a transition to another, stable world, but to a situation in which everything – customs, habits, lifestyles, the material environment – remained in flux, in a purgatorial state of never leaving and never arriving. Imagine the odd mixture of fear and excitement that would inevitably flow through you, and how this would change your view of the world and your place in it.

Art Nouveau arrived in a world such as this. It was a style in the visual arts born of the transformation of society through the modernization of the very means of existence. Between 1870 and 1900 the cities of Europe and North America swelled

beyond imagination in a spectacular urban revolution which led to generations of city dwellers coming to view their 'natural' environment to be one coated with brick, steel and tarmac. Beyond the city, commerce and technology, backed by formidable military machines, took control of the earth and made it self-consciously cosmopolitan. These changes to lived experience caused similar ones in the psychological and intellectual outlook of the individual. Physical change on such a scale is inevitably accompanied by an equal shift in the metaphysical realm. This was not simply an age of cities and machines, but also of traumas and ghosts.

Art Nouveau is best defined as a style in the visual arts that came to the fore in a number of European and North American cities from the early 1890s, and remained a force to be reckoned with until the end of the first decade of the twentieth century, when it faded quite speedily from view. The style emerged from the intense activity of a collection of movements, manufacturers, public institutions, publishing houses, individual artists, entrepreneurs and patrons. Its main areas of activity were in the decorative arts, though it affected all forms of visual culture.

The defining characteristic of Art Nouveau – the factor that made it into an intellectually and socially cohesive force – was modernity. It was the first deliberate, internationally based attempt to transform visual culture through a commitment to the idea of the modern. In a world that was being voraciously modernized, it was inevitable that artists and designers would attempt to modernize culture, so that it

could remain relevant to the people it was created for. It was intended to be a style *for* the age; we now recognize it as the style *of* the age.

Several factors make the beginnings of Art Nouveau difficult to discern. Many artists, designers and thinkers before 1890 anticipated it without being part of it, and many key Art Nouveau designers had long careers in related styles before they became involved in Art Nouveau itself. Nevertheless, a pattern of development can be traced, which reveals the style to have had three broad phases.

In the initial period, 1893 to 1895, the first fully mature works emerged from a myriad of related activity in London, Brussels and Paris. Individual artists and designers began to produce consistent bodies of work in the style, and the intellectual agenda was worked out. Most importantly, perhaps, an infrastructure for presenting and selling objects and ideas was put in place. Many things happened, but four outstanding creative moments can stand as a summation of these years.

The first occurred in London. In March 1893 in the first issue of a new journal, *The Studio*, the work of a startlingly young illustrator, Aubrey Beardsley, was featured. This was the first public presentation of his work and it immediately made him the centre of attention among the European and North American *avant-garde*. One of the published illustrations, *J'ai baisé ta bouche Iokanaan* for Oscar Wilde's play *Salome*, was the first fully mature image in the Art Nouveau style (*plate 1*).

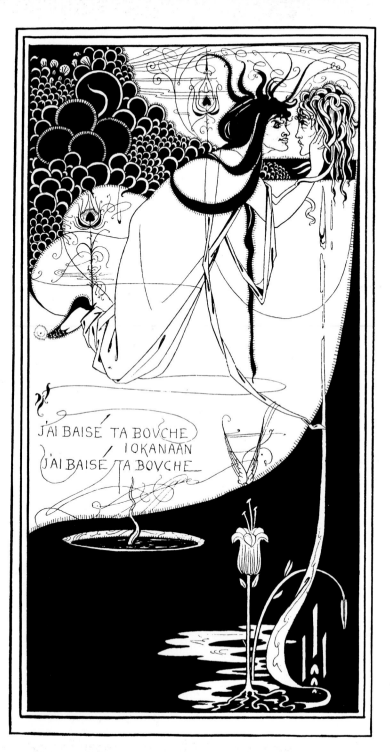

1 Aubrey Beardsley:
J'ai baisé ta bouche Iokanaan.
Print from Oscar Wilde's
Salome. English, 1893.
V&A: E.456-1899.

2 Victor Horta: first floor
interior view of the Tassel House.
Brussels, 1893.

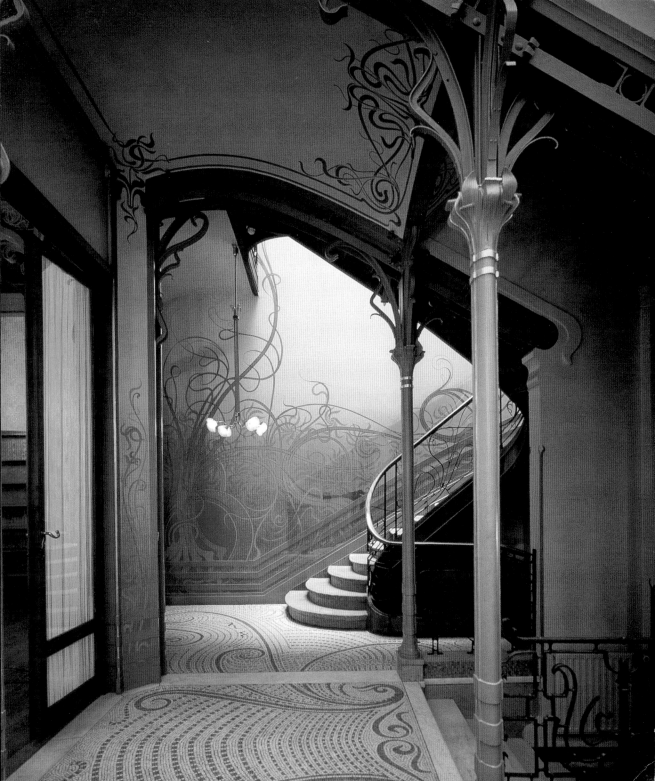

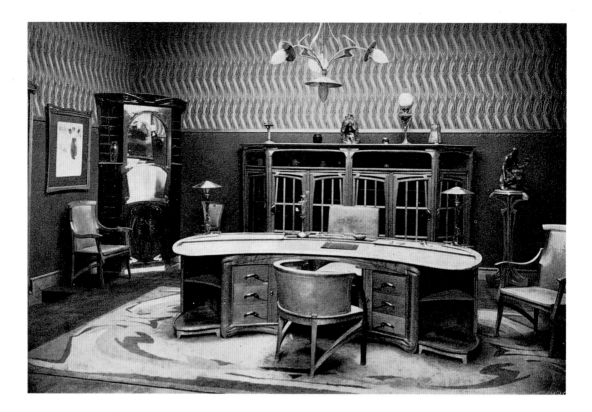

The second creative moment, also in 1893, occurred in Brussels. Most certainly in ignorance of Beardsley's efforts, but inspired by much the same things, the young architect Victor Horta completed a commission from his patron, the industrialist Emile Tassel, for a terraced town house in the St-Gilles district of the city. The house was the first fully developed exercise in Art Nouveau architecture and interior design (*plate 2*).

The third, in 1894 and also in Brussels, saw Henry van de Velde publish, in pamphlet form, *Déblaiement d'Art* (A Clean Sweep For Art), which gave an intellectual context to his actions of the previous two years. *Déblaiement d'Art* spoke for a new generation of artist-designers who believed that the art world had become moribund, institutionalized and corrupt. Written in a spirited, Romantic style, it was effectively

3 Henry van de Velde:
interior 1899.
V&A: NAL.

a call to arms for the new generation: 'The time has come; the idea of love will be communicated to all men; art will return to the light in a new form...the new flower will rise; but we will not see this rise before the complete obliteration of the present'. In his writings and his brilliant design work, van de Velde powerfully promoted two of the ideas that were to become central to the style. The first of these was to do with the perceived status of the decorative arts and design in relation to the 'higher' arts (generally referred to as the 'fine' or 'beaux' arts). In a blistering article written in 1895, he made his position clear:

> Suddenly they were called arts of the second rank, then decorative arts, and then the minor arts... and last, industrial arts... It is important to note that all terminology, like low art, art of second rank, art industry, decorative art and arts and crafts are only valid as long as long as one agrees to them...We can't allow a split which aims at single-mindedly ranking one art above the others, a separation of the arts into high art and a second class, low industrial art.

The second idea, which relates closely to the first, was that all the arts should work in harmony to create a total environment. The idea of 'a total work of art', or *gesamtkunstwerk*, was widely discussed in relation to Wagner's operas. Now the idea was that everything in an interior should relate to everything else. The designer became an orchestrator of all the artefacts that created a room, from wallpaper and textiles to furniture and lighting. Van de Velde's architecture and interior design – alongside many other Art Nouveau designers – lived up to this maxim (*plate 3*).

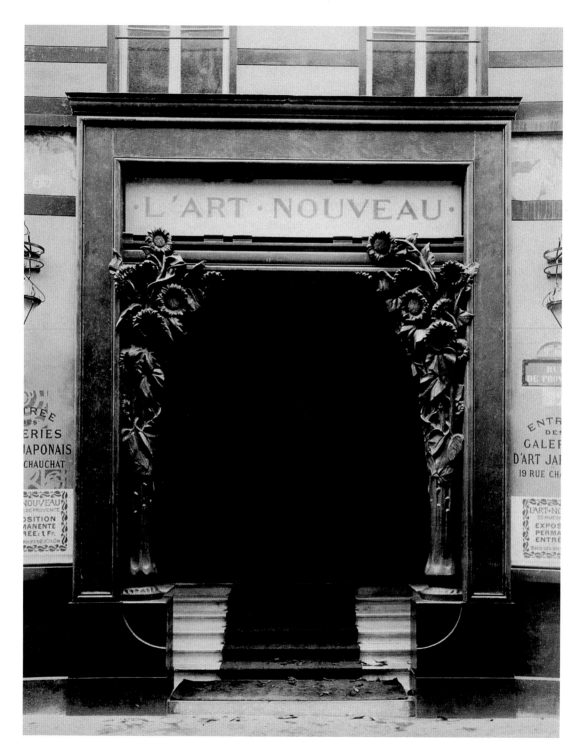

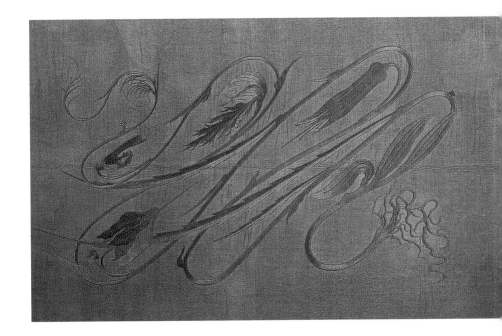

4 Entrance to Siegfried Bing's shop, L'Art Nouveau, Paris 1895.

5 Hermann Obrist: *Whiplash (Peitchenhieb)*. Textile, *c*.1895. Stadtmuseum, Munich.

The fourth creative moment came in December 1895, in Paris. The German-born French entrepreneur Siegfried Bing opened a new gallery on the rue de Provence in Paris. The Gallery was named 'L'Art Nouveau' (*plate 4*). The style thus acquired one of its most active centres of distribution and its most enduring and widely used name. It also confirmed the role of the French capital in the life of the style. Many designers lived and worked in Paris and, perhaps more significantly, Art Nouveau was powerfully promoted and sold there.

By late 1895, the new style was beginning to flourish all over Europe. In Glasgow, Munich, Vienna and Nancy, for example, breakthroughs were made that added to the steadily growing popularity of the style. One of the most famous of these was a set of embroideries by German designer Hermann Obrist – one became known as 'whiplash', and as such it typified a use of line common among Art Nouveau designers (*plate 5*).

Speed characterized the spread of Art Nouveau from 1895. The second phase, from 1895 to 1900, saw it grow in urban centres in Europe and North America. By 1900 many towns and cities supported a version of the style, including (in addition to those already mentioned) Amsterdam, Antwerp, Barcelona, Berlin, Budapest, Darmstadt, Helsinki, Milan, Moscow, Nancy, New York, Oslo, Prague, Riga and Turin. In some of these, such as Copenhagen and Chicago, a small number of inspired individuals created masterworks in architecture and design. In others, such as Nancy, the style under-pinned large-scale industries and became an essential component of the life of the community.

The third phase, 1900 to 1914, saw the style become a widely known, practised and discussed phenomenon, an omnipresence on the international cultural scene and subject both of loud celebration and condemnation. Art Nouveau had become mainstream, a trade standard that could be applied to goods of all kinds – at the top and bottom of the market – to bestow it with the cachet of modern living. During this phase some of the designers and entrepreneurs who had been central to its growth began to condemn the style as vulgar and debased.

Art Nouveau was a style dependent on a market committed to the consumption of modern luxury goods. Designers embraced rapidly developing organs of promotion and dissemination to sell their wares to the widest audience possible. Advertising, department stores, magazines, mail order, trade fairs and International Exhibitions

6 Plate 64 from *Le Castel Béranger,*
ouevre de Hector Guimard, Architecte (Paris, 1898).
V&A: NAL.

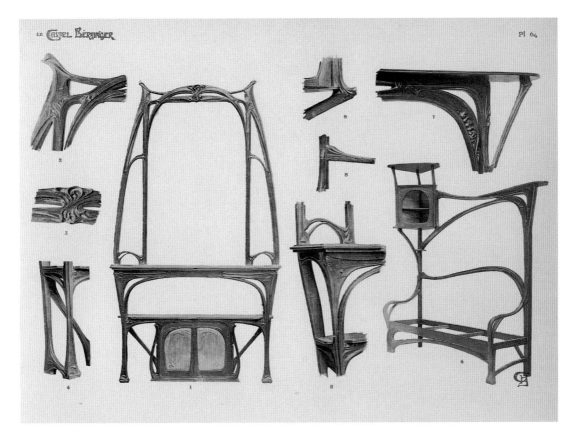

(Expos) gave unprecedented opportunity for the sale of modern dreams. Architect-designer Hector Guimard, for example, an accomplished self-publicist, generated his own literature to show his patrons what was available in 'Le Style Guimard' (*plates 6 and 7*).

LE CASTEL BÉRANGER

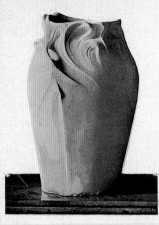

3

7

8

9

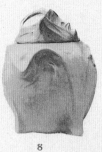

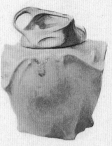

11

10

5

1

2

6 Plate 64 from *Le Castel Béranger,*
ouevre de Hector Guimard, Architecte (Paris, 1898).
V&A: NAL.

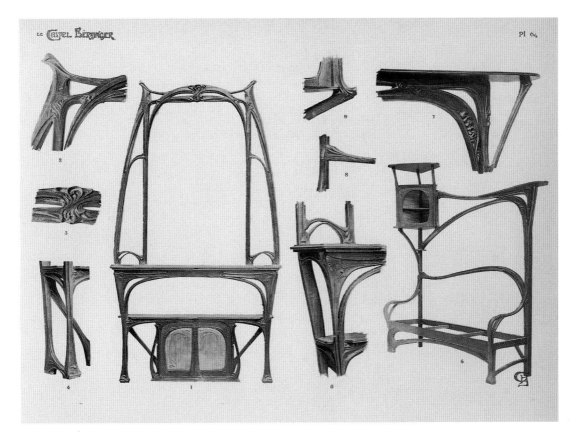

(Expos) gave unprecedented opportunity for the sale of modern dreams. Architect-designer Hector Guimard, for example, an accomplished self-publicist, generated his own literature to show his patrons what was available in 'Le Style Guimard' (*plates 6 and 7*).

3

7

8

9

11

10

5

1

2

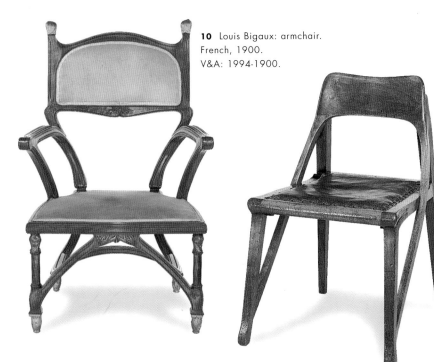

10 Louis Bigaux: armchair. French, 1900. V&A: 1994-1900.

11 Richard Riemerschmid: chair. German, 1900. V&A: Circ.859-1956.

13 Charles Rennie Mackintosh: chair. Scottish, 1897-1900. V&A: Circ.130-1958.

art were at the heart of various movements (*plates 9 and 15*). The oval and the cabriole leg are taken from the Rococo (*plates 10, 13 and 17*). The classical reserve of the Biedermeier style crept into many designs (*plate 12*). Gothic Revival theories are evident in the buttressed, structural logic of plates 8, 10 and 11. Several of the chairs appear to have symbolic intent, in that they seem to contain partly submerged meanings. The sinuous, organic forms and flower motifs seen in most of the chairs are derived from the study of stems, sepals and other parts of plants.

14 Antoní Gaudí: chair.
Spanish, c.1903.
Casa Calvet.

17 Louis Majorelle:
chair. French, 1900.
V&A: 2001-1900.

16 Odön Farago: chair.
Hungarian, 1899-1900.
V&A: 144-1901.

15 Gerhard Munthe: armchair. From
the Fairytale Room, Holmenkollen
Tourist hotel. Norwegian, 1896. Norsk
Folkmuseum, Oslo.

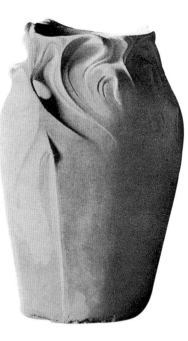

7 Plate 65 from *Le Castel Béranger, ouevre de Hector Guimard, Architecte* (Paris, 1898).
V&A: NAL.

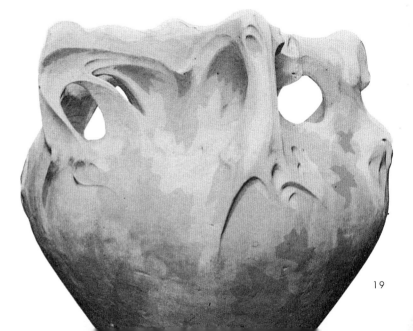

As with all major stylistic developments in the history of art, such as the Gothic, the Baroque or neo-Classicism, the Art Nouveau style was diverse. Every national centre added their own inflections and interpretations to the whole, and within each centre different individuals and groups created variety and conflict at a local level. All styles are enriched by the circumstances in which they are made. Underlying this variety, however, were outlooks and ideas held in common that gave the style its cohesiveness as well as its international significance.

There are several types of source that Art Nouveau designers looked towards to achieve their respective modern 'looks'. The first and most important was nature. Animals, plants and landscape formations dominate a large number of the movements that constitute Art Nouveau. After this, most schools experimented with certain previous historical styles, twisting and re-arranging them to make them visually and symbolically appropriate to the modern age. Art Nouveau designers did not use historical forms simply to evoke the past or to imbue their designs with a veneer of respectability. Rather, they tended to re-interpret history, using it to their own ends. Key historical styles were various forms of Classicism, the Baroque, Rococo and Biedermeier styles, the Gothic Revival, Viking, Celtic and Folk Art. Designers were also heavily reliant on historical styles from outside Europe. The art of Japan and the Islamic nations were by far the most important sources here, followed by China. Some countries made use of the cultures they controlled through imperial conquest. Central African art, for example, affected various Belgian designers, and Indonesian patterns were important in Holland.

Finally, the various forms of Symbolist art, including literature, were vitally important for the development of Art Nouveau. French Symbolism was especially significant for the imbuing of a sense of mystery and psychic depth to objects and images.

Art Nouveau was an extremely eclectic style: that is to say, both the look of the objects and the meanings they convey were achieved through the combination of many other styles and ideas. These would be deliberately brought together to create a certain effect. Many Art Nouveau objects are deceptively simple, their simplicity masking a complicated combination of visual ideas from wildly diverse places. Often, several of the historical styles would be mixed together and then shrouded with natural forms and symbolist meanings. It was a complicated style for a complicated age, when many contrary forces were forced to live together: the old and the new, the city and country, science and religion, the individual and the community, the local and the cosmopolitan.

The men and women who created Art Nouveau believed that all the arts should work in tandem, that if the objects of everyday existence contained poetry, then the mass of people might partake of poetry. It was a radical attempt to decorate the world so as to give it more meaning. As such, it set the agenda for many of the modern movements which followed it.

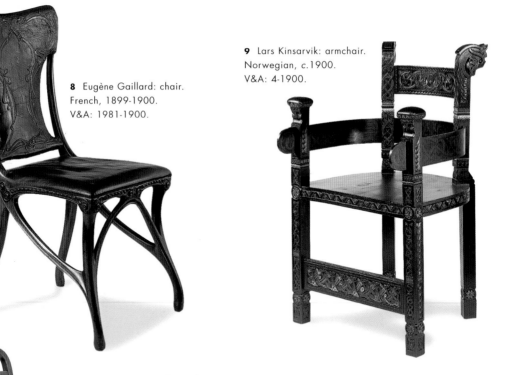

8 Eugène Gaillard: chair. French, 1899-1900. V&A: 1981-1900.

9 Lars Kinsarvik: armchair. Norwegian, c.1900. V&A: 4-1900.

12 Josef Hoffmann: chair. Manufactured by Thonet. Austrian, c.1905. V&A: W.42-1979.

The ten chairs illustrated here show the diverse means designers used to create the Art Nouveau style. Some of the chairs make heavy use of a sinuous, curving line that derives partly from Japanese and Islamic art (*plates 8, 10, 11 and 17*). The aggressive simplicity, asymmetry and flat-patterning of Japan is also in evidence (*plates 13 and 15*). The vernacular (folk) tradition appears in the form of references to local myths, legends and symbols (*plate 16*), and more subtly in forms and surfaces that are not overtly rural in intent (*plates 11, 12, 13 and 15*). Related to the folk tradition, ancient Celtic and Viking

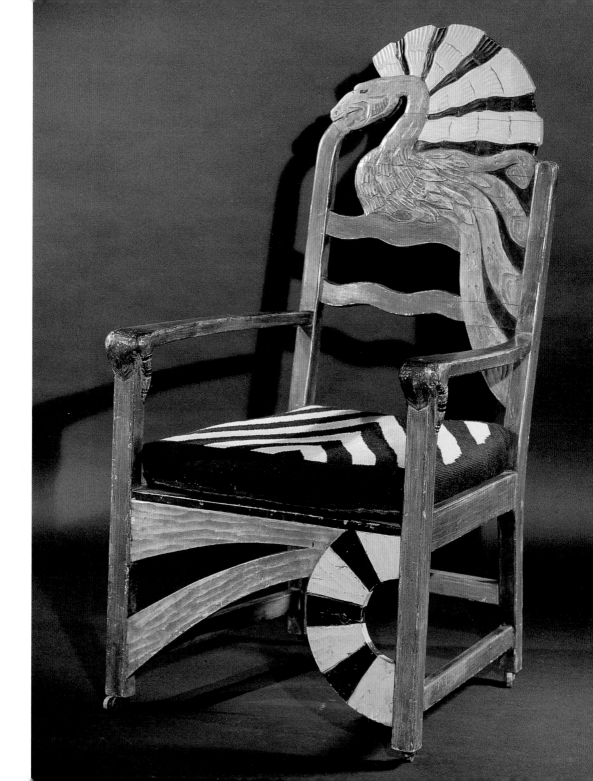

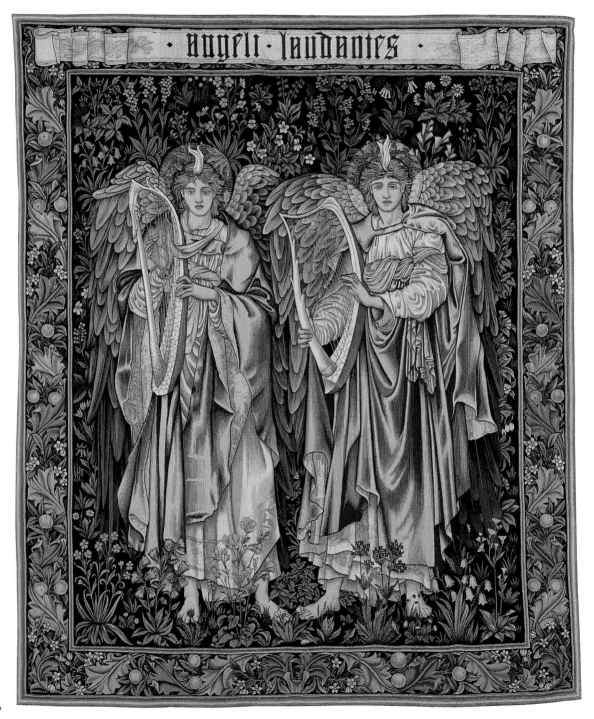

26

ENGLISH STYLE

It was accepted by most major schools practising in the Art Nouveau style that English design was a major example and inspiration. Most prominent influences include William Morris and the Pre-Raphaelites (*plate 18*), and the Arts and Crafts movement (*plates 19, 20 and 21*). The Aesthetic movement, led by such eminences as Oscar Wilde, James McNeill Whistler and E.W. Godwin (*plate 22*) preached an elegant simplicity that proved important. Alongside these various visual influences, the moral discourses of John Ruskin provided many of the Europeans with their political commitment to design reform. The entrepreneur Arthur Lasenby Liberty, through his remarkable department store, disseminated the new aesthetics across the face of Europe.

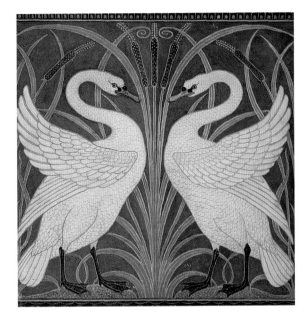

18 Edward Burne-Jones: *Angeli Laudantes*.
Tapestry woven in coloured wools and silks by
Morris & Co. English, 1894.
V&A: 153-1898.

19 Walter Crane: wallpaper design. English, 1875.
V&A: E.17-1945.

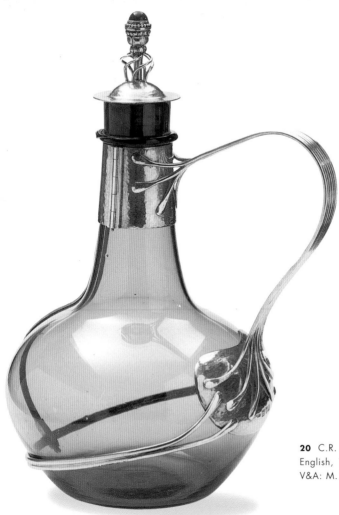

20 C.R. Ashbee: decanter.
English, 1904.
V&A: M.121-1966.

Despite the contribution of the English school, Art Nouveau did not develop into a fully formed movement in any major English city. Individual designers and companies produced fine examples, these often selling well abroad, but the home market, and most of the nation's best practitioners, remained stubbornly resistant to the style.

21 C.F.A. Voysey:
silk bedcover. English,
produced by G.P. &
J. Baker c.1895
using Voysey design
of c.1888.
V&A: 5-1986.

22 E. W. Godwin:
cabinet. English, 1867.
V&A: Circ.38-1953.

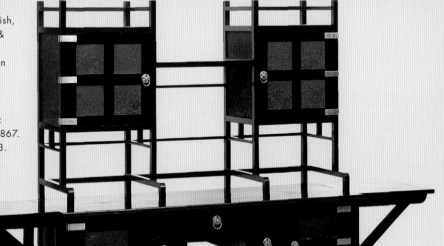

FRENCH SYMBOLISM

French painting of the period 1880 to 1900 provided Art Nouveau with much of its narrative content and many of its forms. Post-impressionists – artists determined to move on from Impressionism, such as Toulouse Lautrec (*plate 23*) –

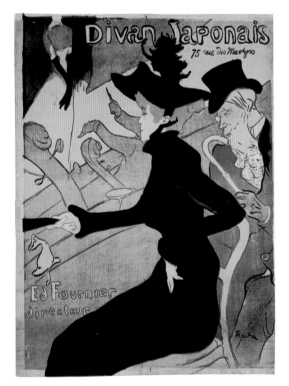

are often included in the Art Nouveau camp. The Pointillist movement, especially as it became embroiled in anarchist politics and various forms of mysticism in the 1890s, gave powerful intellectual guidance. A number of Pointillists went on to become mainstream Art Nouveau designers (*plate 24*).

23 Henri de Toulouse Lautrec: *Divan Japonais*. French, 1892. V&A: E.233-1921.

24 Paul Signac: *Portrait of Félix Fénéon*. French, 1890. Private collection, New York.

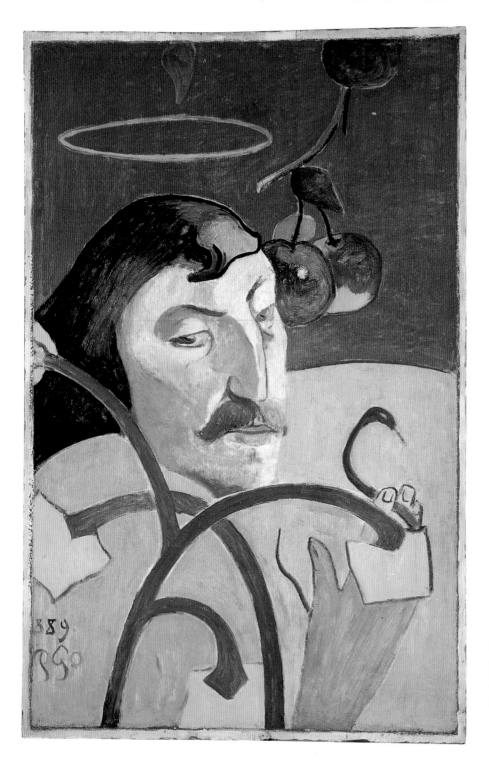

25 Paul Gauguin:
Self portrait. French, 1889.
National Gallery of Art,
Washington. Chester Dale
Collection.

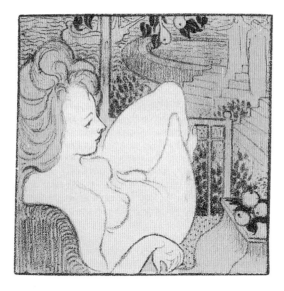

26 Maurice Denis:
Plate 36 from André Gide's
Voyage Sur L'Océ Pathétique
à Henri de Regnier
(Paris, 1893).
V&A: NAL.

The French Symbolist painters, powerfully influenced by literary Symbolism, were committed to the exploration of the metaphysical. They viewed art as a means of discovering the soul, the parts of existence which modern materialism appeared to have left behind. The Nabis group, consisting of a group of young painters deeply under the influence of Paul Gauguin (*plate 25*), was formed in 1888 under the leadership of Paul Serusier and Maurice Denis (*plate 26*). The group also included Pierre Bonnard, Eduard Vuillard, and Felix Vallotton (*plate 27*).

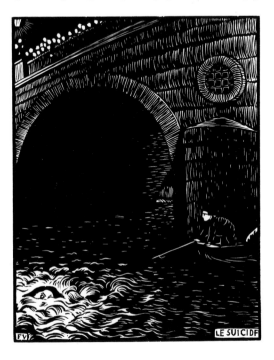

27 Félix Vallotton: *The Suicide*. Woodcut print. French, 1894.
V&A: E.1554-1926.

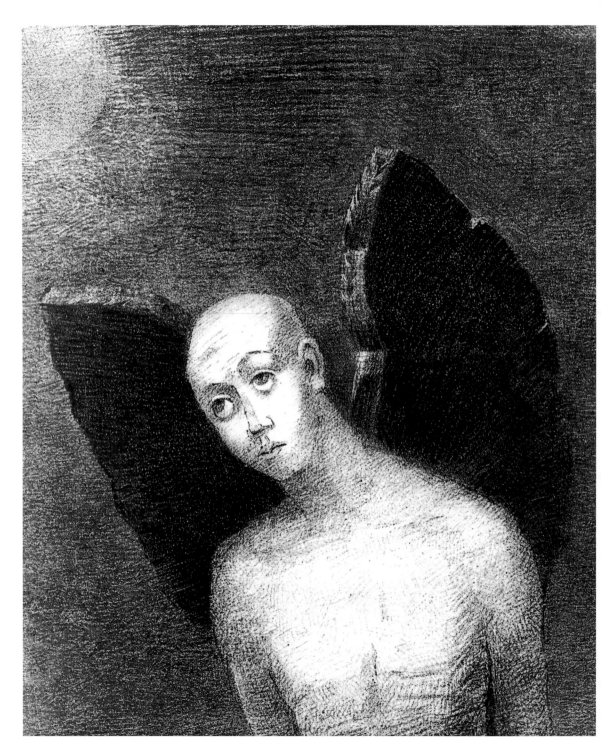

34

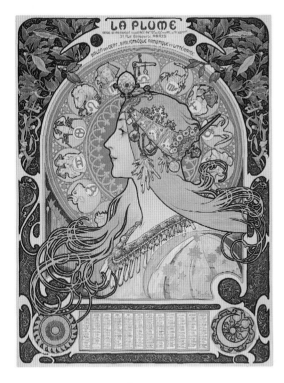

29 Alphonse Mucha:
La Plume. Czech, 1896.
V&A: E589-1953.

Between 1892 and 1897, a Salon was started under the title 'Salon de la Rose+Croix'. Largely organized and selected by mystic Sâr Joséphin Péladan, it represented a wide range of Symbolist activity as it related to mysticism and the occult. Odilon Redon was a great hero of the artists of the Rose+Croix (*plate 28*). Symbolism in France, Belgium and other countries was often displayed alongside Pre-Raphaelitism, Arts and Crafts and Art Nouveau.

Art Nouveau artist-designers such as Alphonse Mucha (*plates 29 and 30*), Emile Gallé, Rupert Carabin, Jean Carries (*plate 31*), Georges De Feure and Jan Toorop (*plate 32*) were deeply affected by the Symbolist heritage.

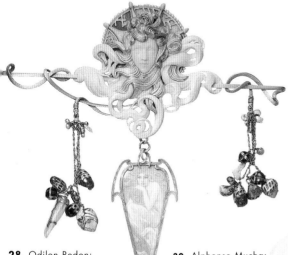

28 Odilon Redon:
plate II from a series of
6 lithographs entitled
Songes (Dreams).
French, 1891.
V&A: E53-1961.

30 Alphonse Mucha:
pendant. Czech, *c.*1900.
Private collection.

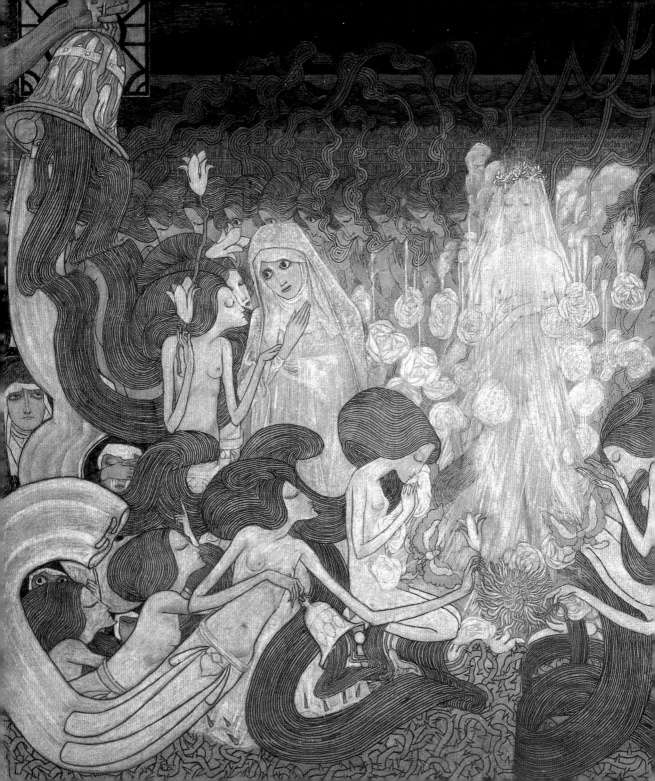

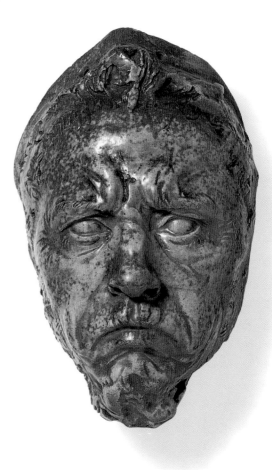

31 Jean Carriès: death mask. French, 1890-02.
V&A: C.60-1916.

32 Jan Toorop: *The Three Brides*. Dutch, 1893.
Kröller Müller Museum, Otterlo.

The Classical Idea

Art Nouveau practitioners didn't seek to reject the Classical past. Given its presence on every level of European culture, this would barely have been possible at that time. Rather, they re-assessed it and transformed it into something that reflected their own contemporary concerns. For a generation, thinkers like Friedrich Nietzsche, Joris-Karl Huysmans and Oscar Wilde had been re-inventing the Classical past, to make it fit in with their own aspirations. In the hands of the *fin-de-siècle* generation, the Classical world became a dangerous place: threatening, erotic, decadent and psychologically troublesome.

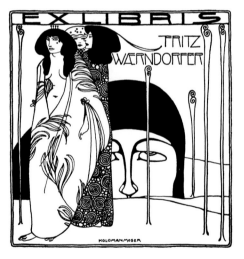

33 Koloman Moser:
The Judgement of Paris.
Book stamp for Fritz
Wärndorfer. Austrian,
1903.
V&A: E.1209-1965.

Of all Art Nouveau centres, Vienna most completely explored the Classical idea to create an art of modern life. The work of Koloman Moser (*plate 33*), Gustav Klimt (*plate 34*), Josef Maria Olbrich (*plate 35*) and Josef Hoffmann (*plate 36*), for example, loses much of its meaning unless read as an ironic exploration and re-orientation of Classical form.

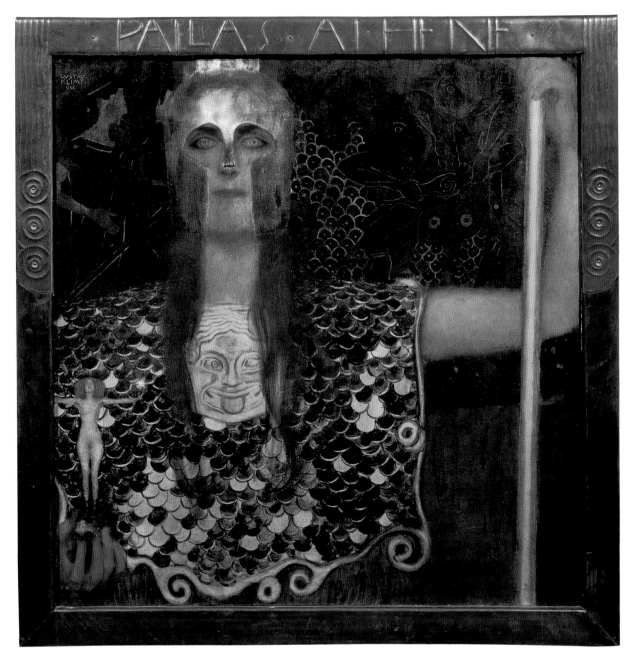

34 Gustav Klimt: *Pallas Athene*. Austrian, 1898.
Historishes Museen der Stadt Wien, Vienna.

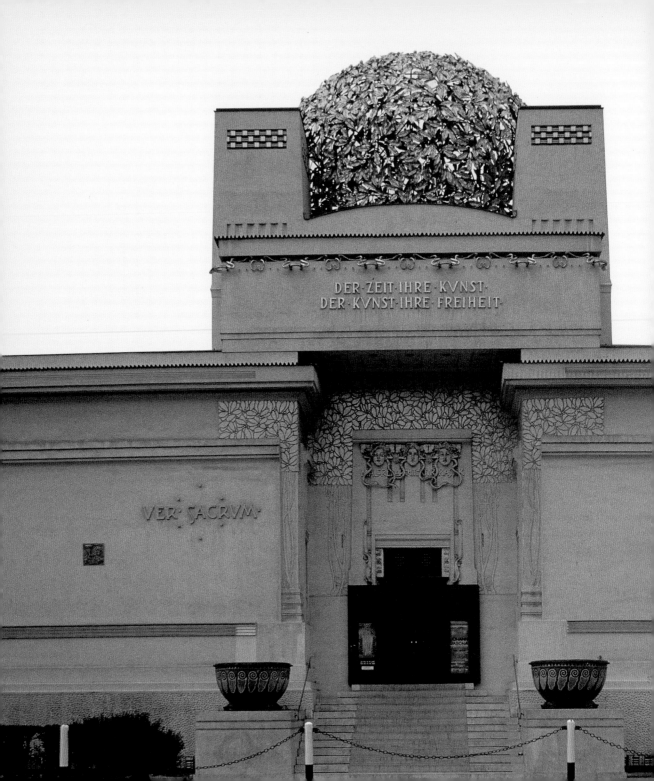

35 Josef Maria Olbrich: Vienna Secession Building. 1897-98.

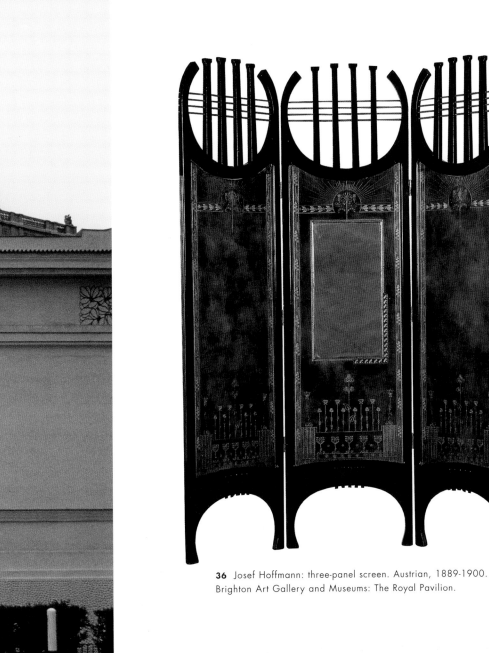

36 Josef Hoffmann: three-panel screen. Austrian, 1889-1900. Brighton Art Gallery and Museums: The Royal Pavilion.

ROCOCO

The Baroque and Rococo styles were popular with Art Nouveau designers all over Europe. Of the two, Rococo was by far the most important. It particularly dominated the major French centres of Paris and Nancy (*plate 37*). The Rococo was a delicate and sensuous development of the Baroque – the distracted, decadent, aristocratic world that it decorated was violently brought to a close by the French Revolution. This partly explains its attraction at the *fin-de-siècle* (*plate 38*).

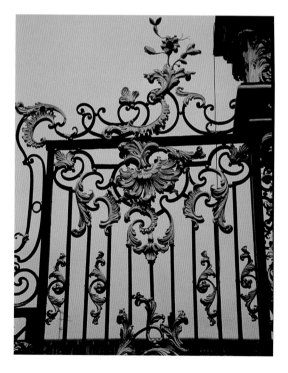

37 Jean Lamour, detail of Place Stanislas gates. Nancy, c.1755.

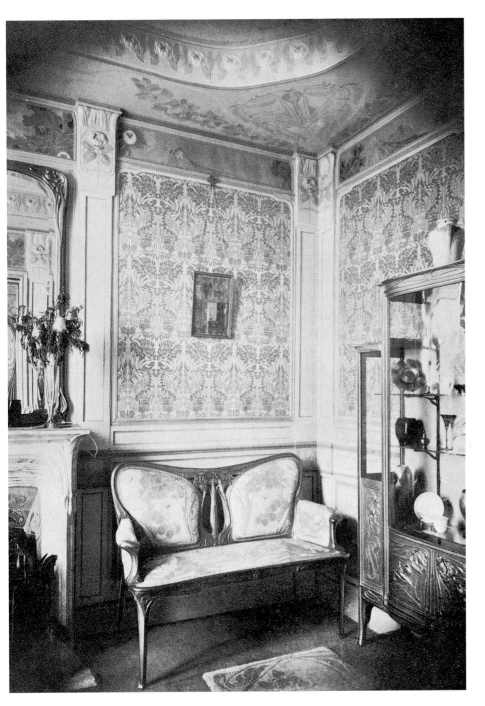

38 Georges De Feure:
room designed for
Siegfried Bing's Pavilion,
Exposition Universelle,
Paris, 1900.
V&A: NAL.

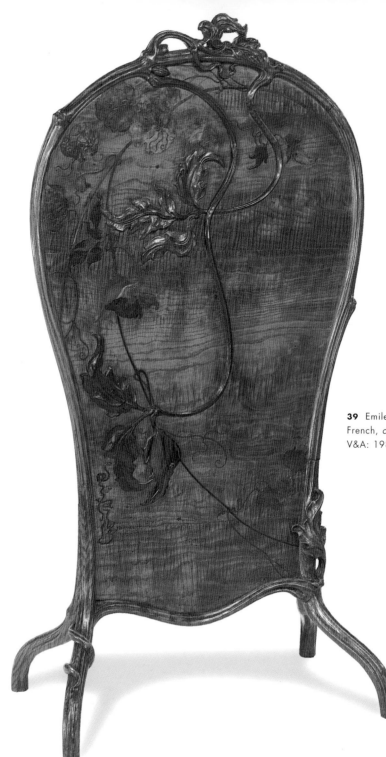

39 Emile Gallé: firescreen.
French, *c.*1900.
V&A: 1985-1900.

The high Rococo style of the Louis XV era, and its various revivals throughout the nineteenth century, effectively became a French national style. The asymmetric, curvilinear profile, use of cabrioles, ovals and floral detailing of this period were a constant presence in Art Nouveau, especially in furniture, ceramics and glass (*plates 39 and 40*). However, for Art Nouveau designers Rococo also carried connotations of decadence and eroticism. At the same time that French state officials were lauding its nobility, novelist Huysmans could see in it only a high, sensual decadence:

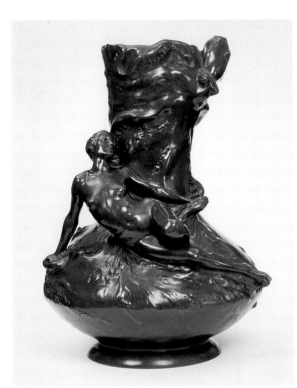

40 Auguste Ledru: vase.
French, 1895.
V&A: M.24-1996.

Visions of the eighteenth century haunted him: gowns with panniers and flounces danced before his eyes; Boucher Venuses, all flesh and no bone, stuffed with pink cotton-wool, looked down on him from every wall... [It] is the only age which has known how to envelop a woman in a wholly depraved atmosphere, shaping the furniture on the model of her charms, imitating her passionate contortions and spasmodic convulsions in wood and copper'.

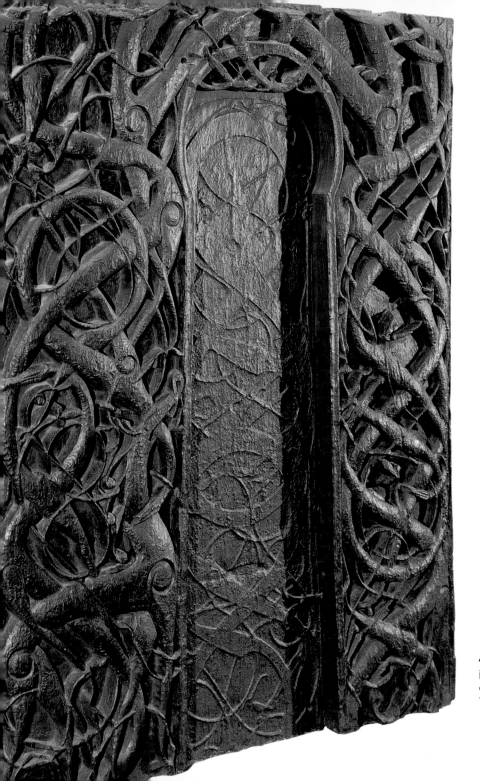
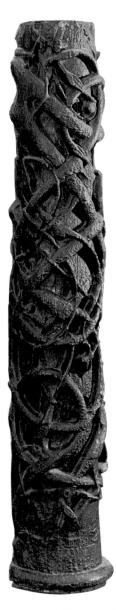

42 Plaster cast of doorway with two
jambs and a pillar from 11th-century
church at Urnes, Norway.
The Cast Courts, V&A: Repro 52-1907.

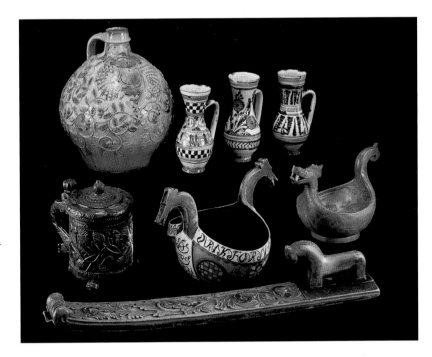

41 Stoneware jug:
German, c.1550.
Earthenware vases:
Hungarian, c.1900.
Tankard, bowls and
mangleboard: Norwegian,
18th and 19th century.
V&A: 4610-1858; C.820-1-
1917; C.823-1917;
W.62-1910; W.104-1926;
570-1891; 599-1891.

FOLK AND ANCIENT ART

Art Nouveau designers frequently embraced styles they perceived to be outside normal expectation. As well as considering non-European art to be 'outside' in this sense, they also identified an 'outsider art' that fell within the boundaries of Europe: folk art. Widely thought to embody pure and honest values, folk art was mimicked in an attempt to achieve unaffected honesty. Some schools sensed in the vernacular an almost religious intensity, of untrained peoples making art forms that were unmediated expressions of the collective life of the community (*plate 41*). Some also felt that local art forms could allow them to engage in political commentary.

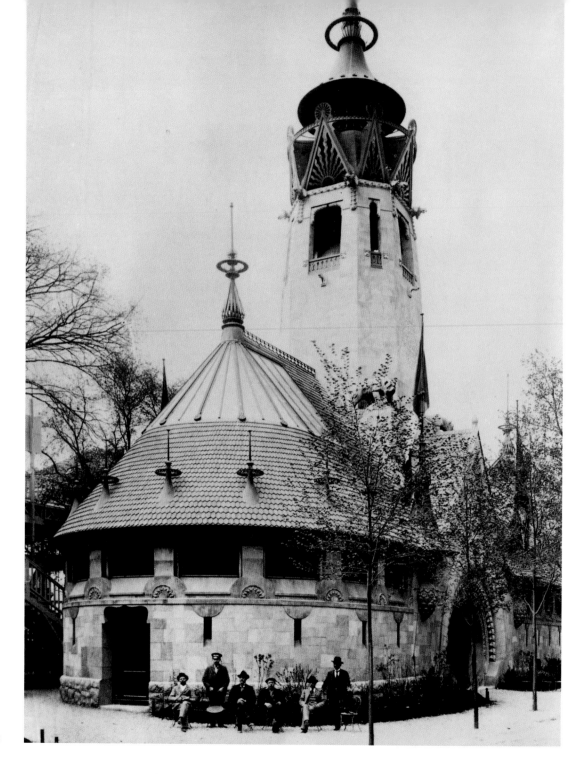

43 Gesellius, Lindgren & Saarinen: Finnish Pavilion for *Exposition Universelle*. Paris, 1900. Museum of Finnish Architecture.

44 Detail of plate 9.

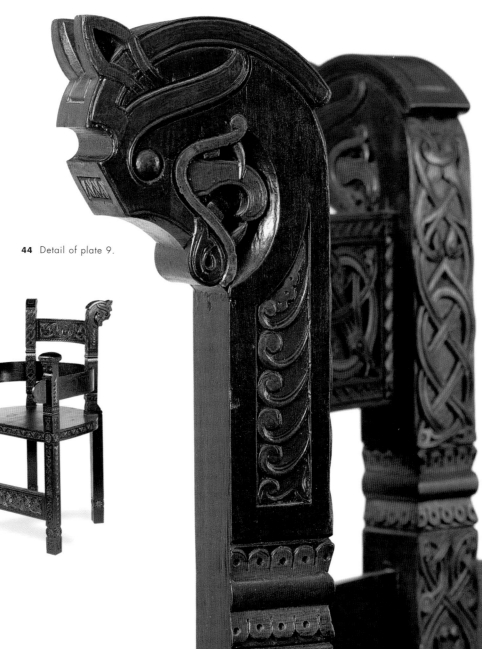

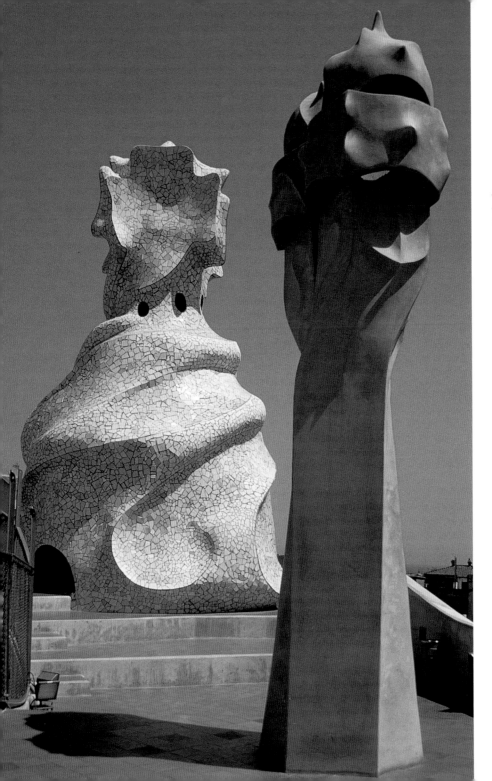

45 Antoni Gaudí: roof of Casa Milà. Barcelona, 1906-10.

46 Illustration from
*Mir Isskustva. c.*1900.
V&A: NAL.

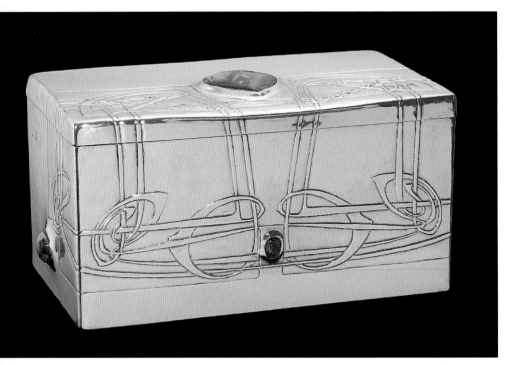

In much the same spirit, Celtic and Viking forms were revived in the Nordic countries, Britain, Ireland and parts of America. The sinuous linear motifs in both these traditions are clearly important for the work of a number of Art Nouveau designers (*plates 42, 47, 48 and 49*). Direct experience of these ancient forms was rare. More usually, designers drew their inspiration from replicas, casts and reproductions viewable at International Exhibitions and in museums.

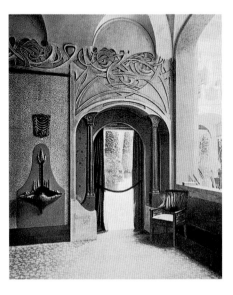

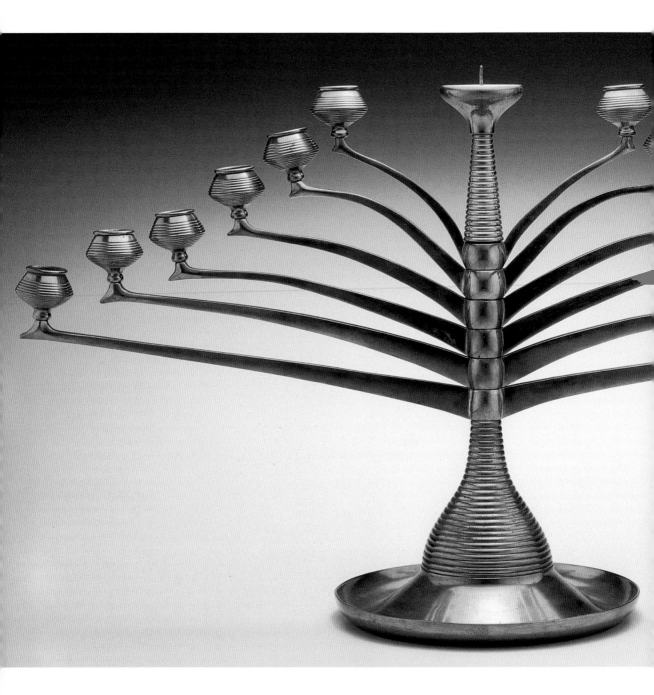

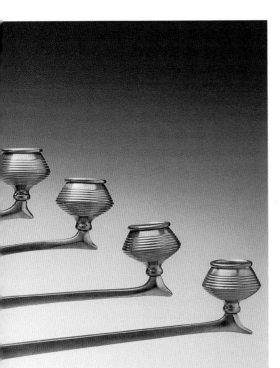

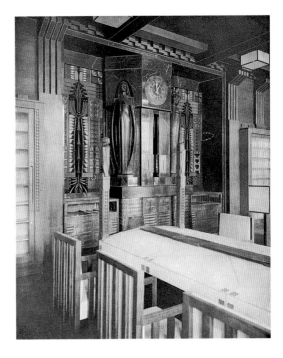

50 Bruno Paul: candelabra.
German, 1901.
Stadtmuseum, Munich.

51 Ödön Lechner: entrance
hall of Museum of Applied Arts,
Budapest. 1896.

52 Peter Behrens: interior
for St Louis Worlds Fair, 1904.
V&A: NAL.

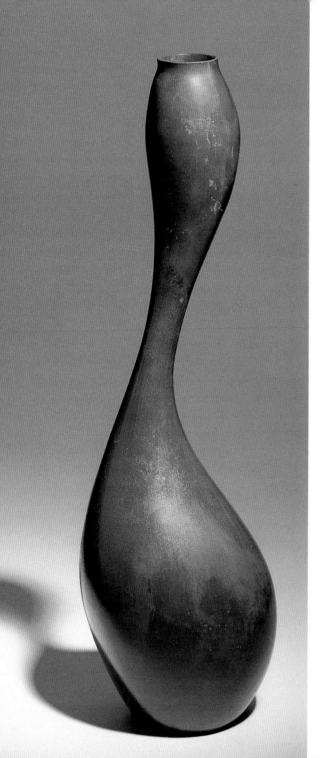

THE EXOTIC

As with many modernists after them, one of the major ways that Art Nouveau designers created a modern look was to take inspiration from art forms outside Europe. The age of Empire, regardless of its social, economic and political shortcomings, provided a great treasure-house of sources for designers. By rejecting European history, they hoped to modernize design. Japanese art and culture was profoundly influential on European design after 1853 when Japan opened itself to the West.

54 Bronze vase. Japan, c.1800-75. V&A: 148-1876.

55 Kimono. Japan,
1840-1870.
V&A: 874-1891.

53 Utagawa Hiroshige: *Awa
Province, Naruto Rapids.*
Woodblock print. Japan, 1855.
V&A: E3605-1886.

56 William H. Bradley:
cover of *The Chap Book*.
American, *c.* 1900.
V&A: E.3035-1921.

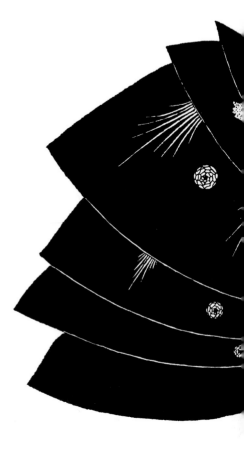

59 Aubrey Beardsley: Detail from
The Black Cape. Print from Oscar
Wilde's *Salome*. English, 1894.
V&A: E427-1972.

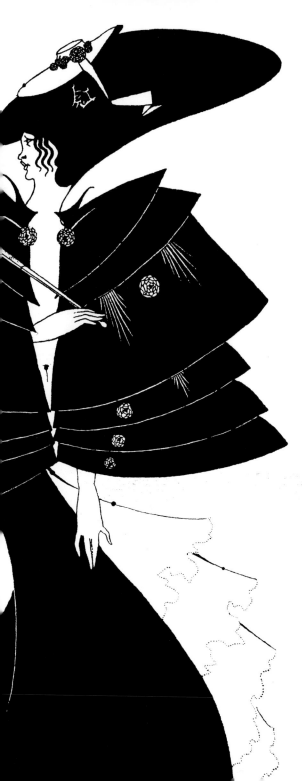

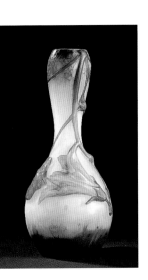

57 Daum Frères: glass vase.
French, 1907-10.
V&A: C.55-1992.

58 Charles Rennie Mackintosh:
settle. Scottish, 1904.
Glasgow School of Art.

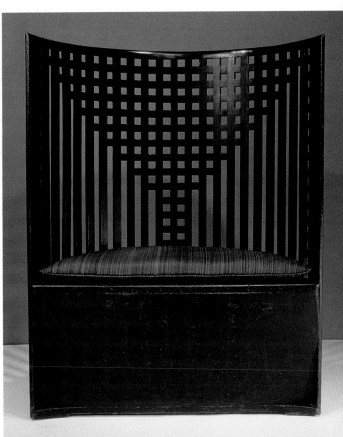

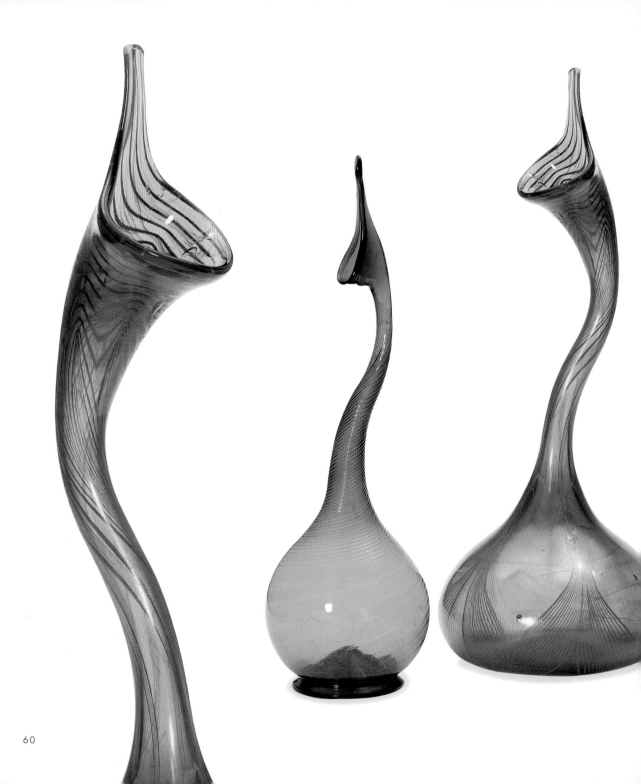

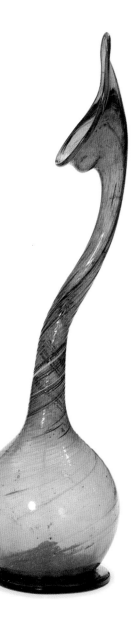

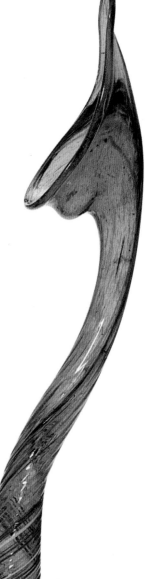

The decorative arts of the Islamic nations had been significant in Europe for centuries, but their influence grew dramatically in the last quarter of the nineteenth century. The curling, linear shape known as the 'arabesque' occurred throughout Islamic textiles, giving form to ceramics and glass (*plates 60 and 61*).

60 Group of three glass flasks.
Centre: Tiffany & Co.,
American, 1896. Left and right:
Persian, c.1885.
V&A: 921-1889; 512-1896;
903-1889.

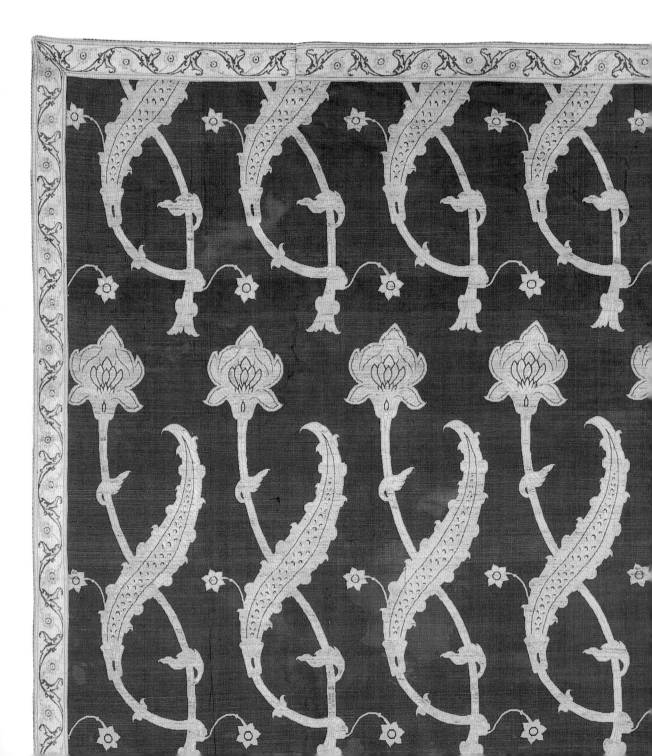

Quite apart from the purely visual influence, Islamic culture exuded a heady sensuality for Europeans, whose sense of the Orient was based on the myth of the exotic Eastern woman (*plate 62*).

61 Woven silk textile.
Persian, 1800s.
V&A: 18-1903.

62 Théodore Rivière:
Carthage or *Salammbô chez Matho*, c.1900.
Brighton Art Gallery and Museums: The Royal Pavilion.

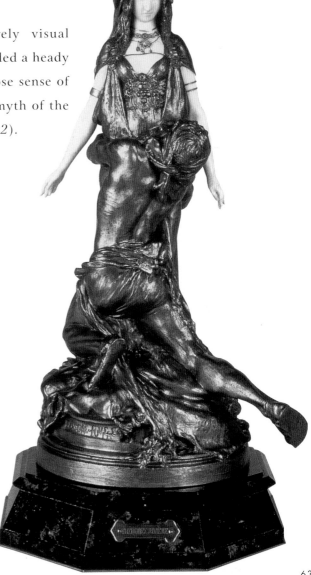

Siphonophorae. — Staatsquallen.

Nature

The most important source for Art Nouveau was nature. More than any other element in the style, it stood for modernity. During the course of the nineteenth century nature became increasingly viewed as a science. The development of evolutionary theory, exemplified by the publication of The Origin of the Species (1859) and The Descent of Man (1871), both by Charles Darwin, fundamentally shifted the position of humanity in the natural scheme of things. Art Nouveau intellectuals related evolutionary theory to cultural processes, suggesting that evolution in nature was analogous to progress in culture.

Designers went beyond traditional naturalism by using forms derived from obscure and exotic plants, under-sea life and microscopy. They found these in the many highly illustrated botanical and biological volumes being published worldwide (*plate 63*). Perhaps the most famous and influential of these volumes were written by German biologist Ernst Haeckel. Many of the designers associated with Art Nouveau had professional qualifications in natural history, and published in academic journals in the field.

63 Ernst Haeckel:
Siphonophorae. Plate 17
from *Kunstform der Natur*.
German, 1898.
V&A: NAL.

64 August Endell:
facade of Hof-Atelier
Elvira. German, 1897-98.

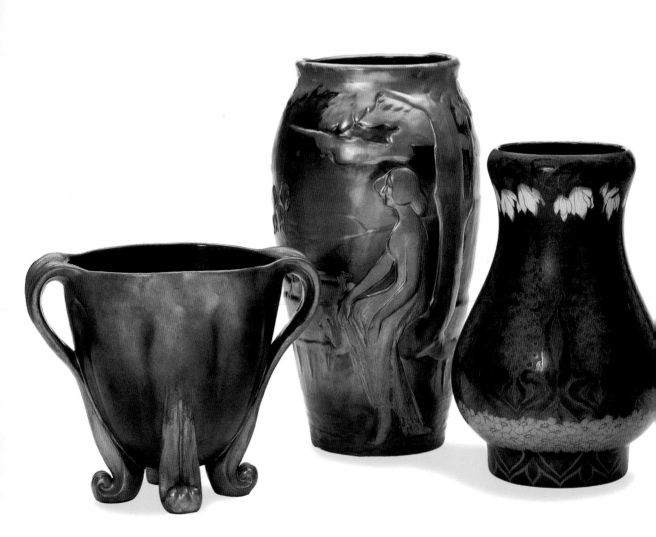

There was no single approach to nature within Art Nouveau – it was used as a basis for pattern forms. Some designers published volumes showing how nature could be re-modelled or conventionalized for use in design (*plates 65 and 67*). Designers would often begin with a realistic depiction of plant or animal forms and then simplify these much in the manner of the painters of the Nabis group, to create coloured friezes and abstracted pattern (*plates 66 and 68*).

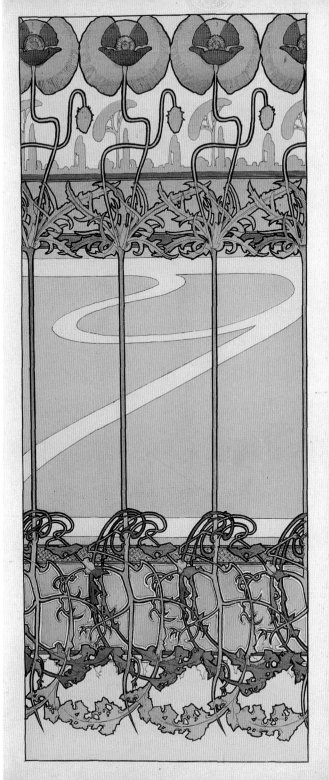

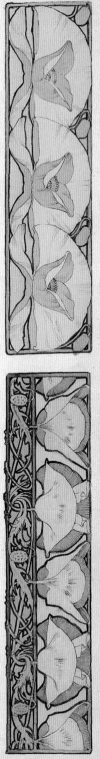

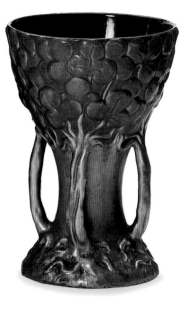

65 Alphonse Mucha:
plate 29 of *Documents
Decoratifs*. Czech, 1902-03.
V&A: NAL.

66 Earthenware made by
Zsolnay. Hungarian, *c*.1900.
V&A: 1951-1900; 1950-1900;
1349-1900; 1350-1900.

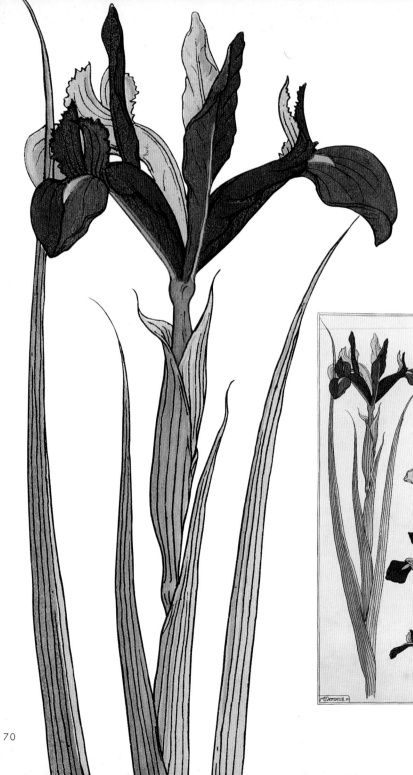

67 Eugène Grasset: Irises. Plate 1 from *Plants And Their Applications to Ornament.* French, 1897. V&A: NAL.

68 Porcelain made by Rozenberg. Dutch, 1909. V&A: C.37:1, 2-1995.

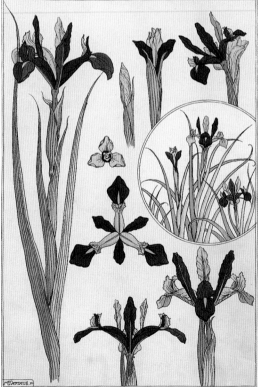

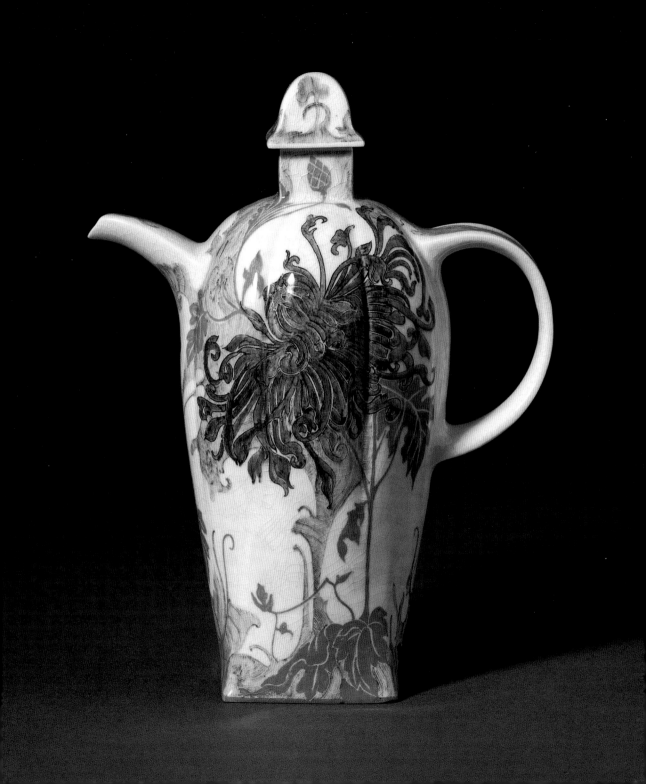

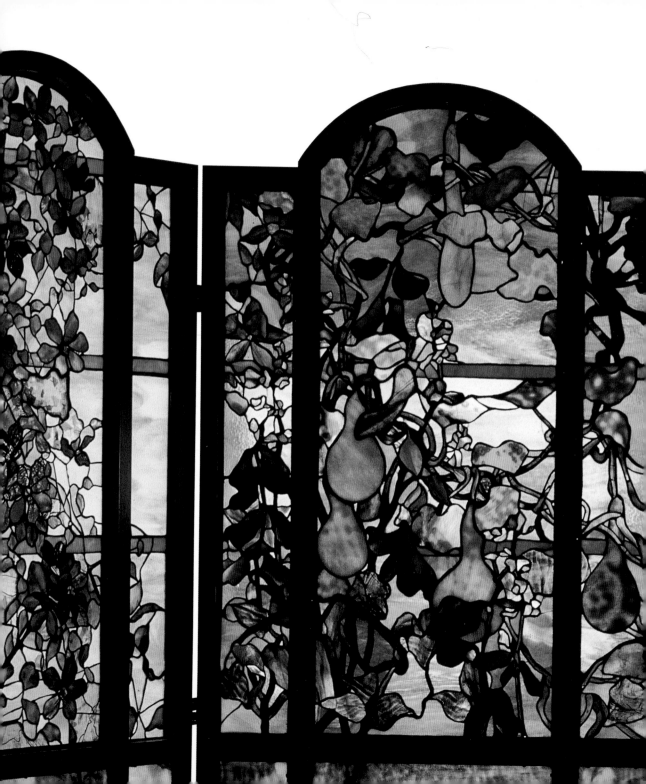

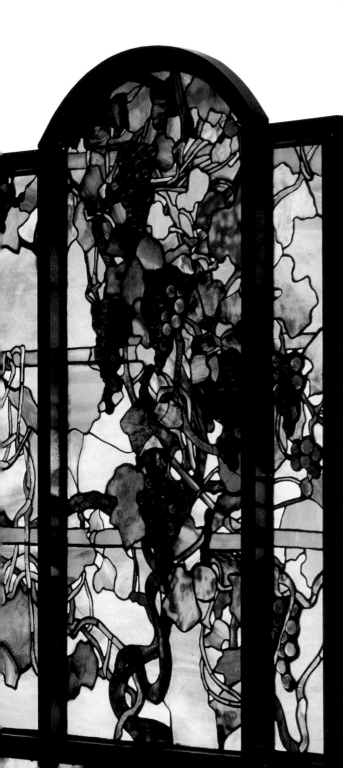

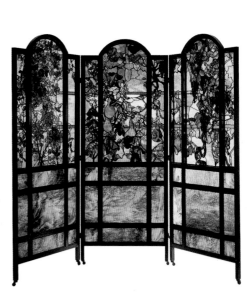

69 Louis Comfort Tiffany:
three panel screen.
American, c.1900.

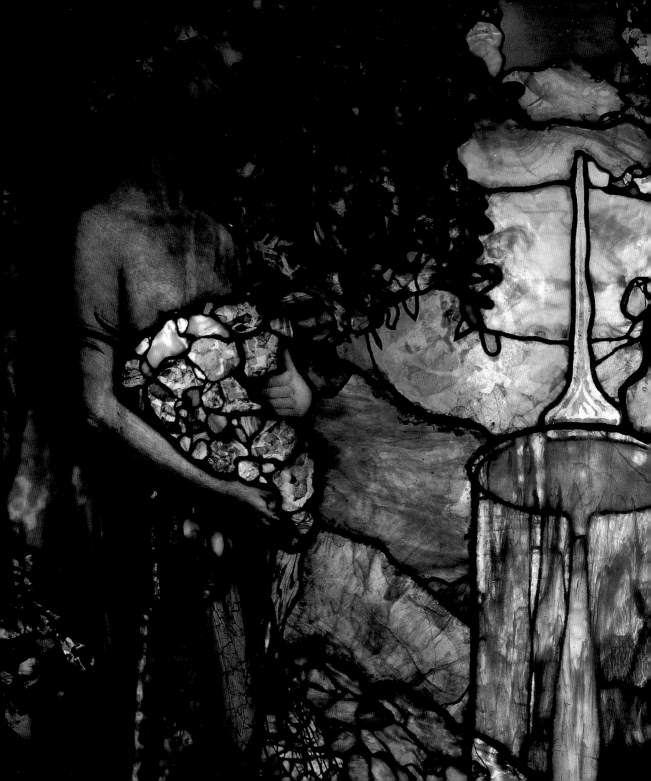

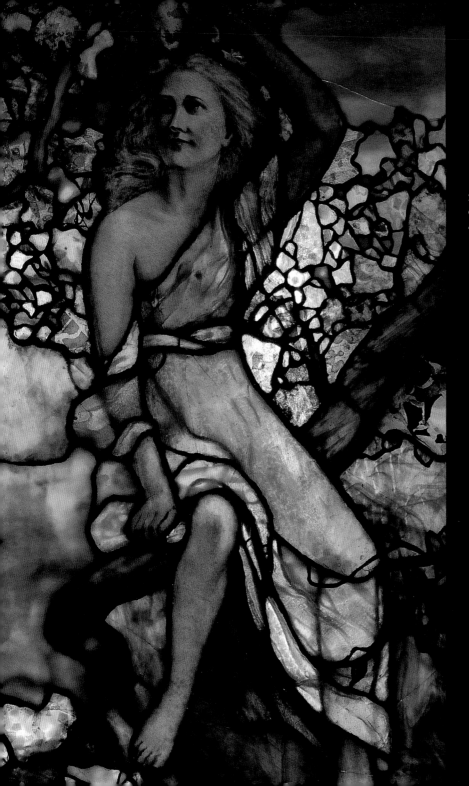

70 Louis Comfort Tiffany:
detail of *Four Seasons* window.
American, 1897.

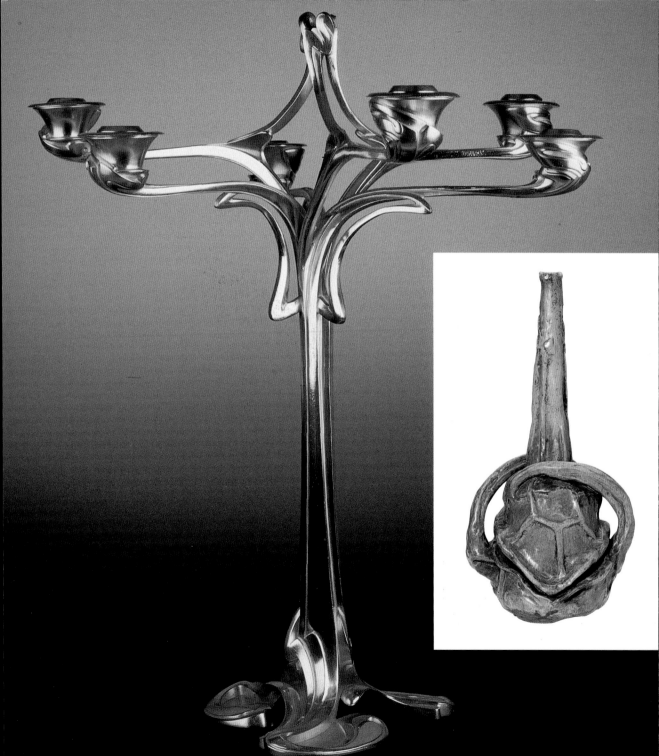

71 Henry van de Velde:
candelabra. Belgian, 1898-99.
Musées Royaux d'Art et
d'Histoire, Brussels.

A far more sculptural approach also developed, in which objects of everyday use were
translated into pure, abstract organic form (*plates 71, 72 and 73*).

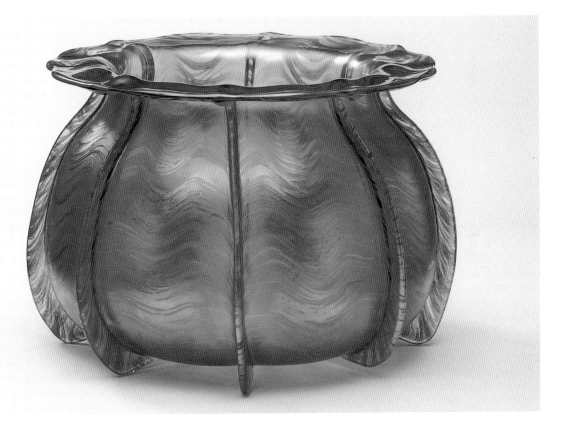

72 George Hoentschel:
stoneware. French, *c*.1900.
V&A: C.60-1972.

73 J. Loetz-Witwe: glassware.
Bohemian, *c*.1899.
V&A: 1305-1900.

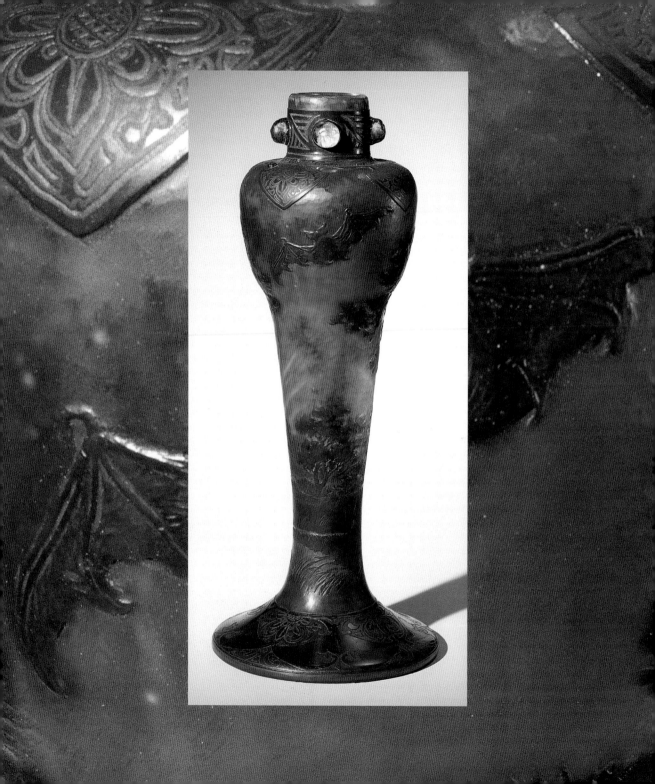

Some designers were pantheists (nature worshippers) and depicted animals and plants with a mystical fervour (*plates 74 and 75*). Many designers used metamorphosis as a strategy, fusing animal, plant and human forms (*plates 76, 77 and 78*).

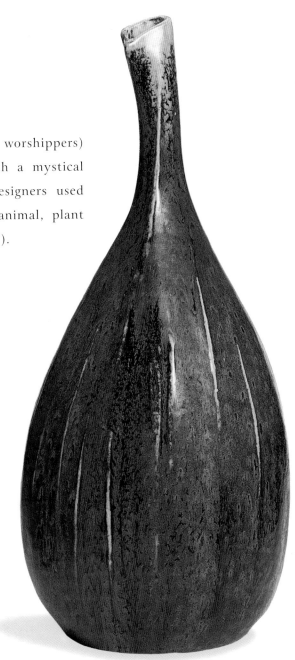

74 Emile Gallé:
glass vase.
French c.1903.
V&A: C.100-1967.

75 Pierre-Adrien Dalpayrat:
stoneware. French,
1893-1900.
V&A: 952-1901.

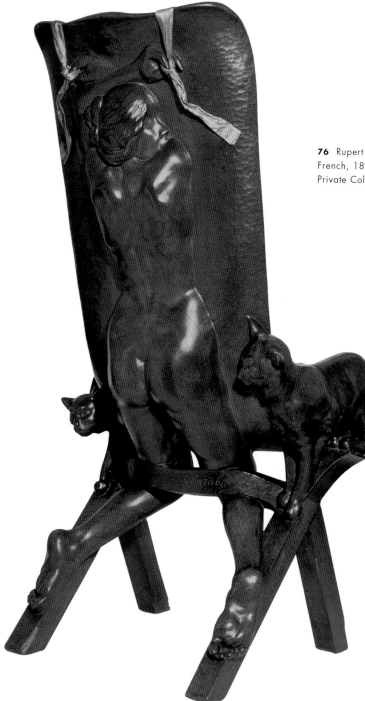

76 Rupert Carabin: chair.
French, 1895.
Private Collection.

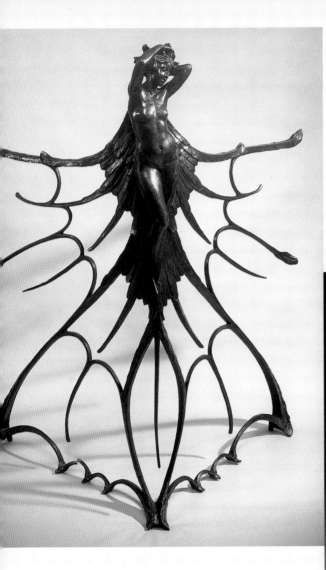

77 René Lalique: winged female figure. Fench, c.1899-1900.
Private Collection, New York

78 Artus Van Briggle: vase. American, 1898.
V&A: C.60-1973.

Nature became the major vehicle for the creation of interiors which were 'total works of art' or *gesamtskunstwerk* (*plates 79, 80 and 81*).

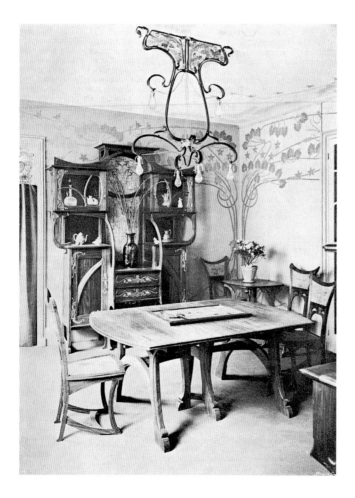

79 Serrurier Gustave-Bovy: dining room. French, 1899. V&A: NAL.

80 Eugène Gaillard: bedroom from Siegfried Bing's Pavilion, *Exposition Universelle*, Paris, 1900. V&A: NAL.

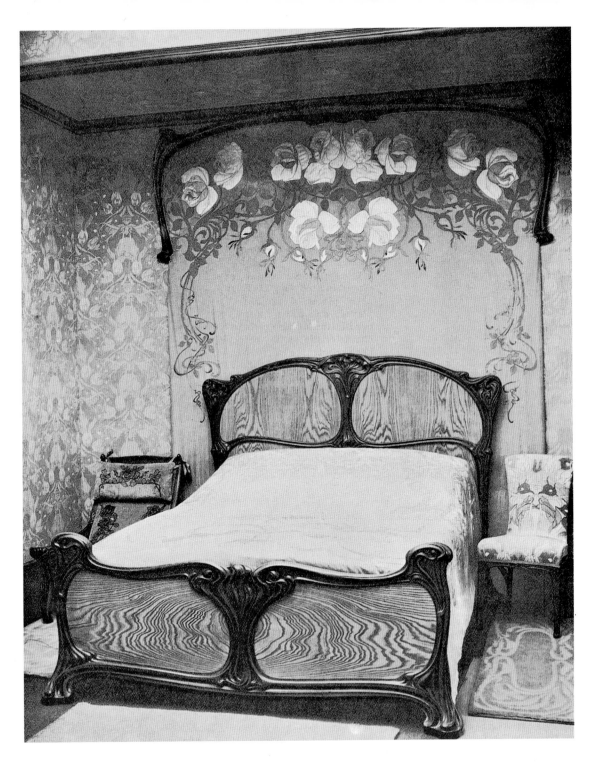

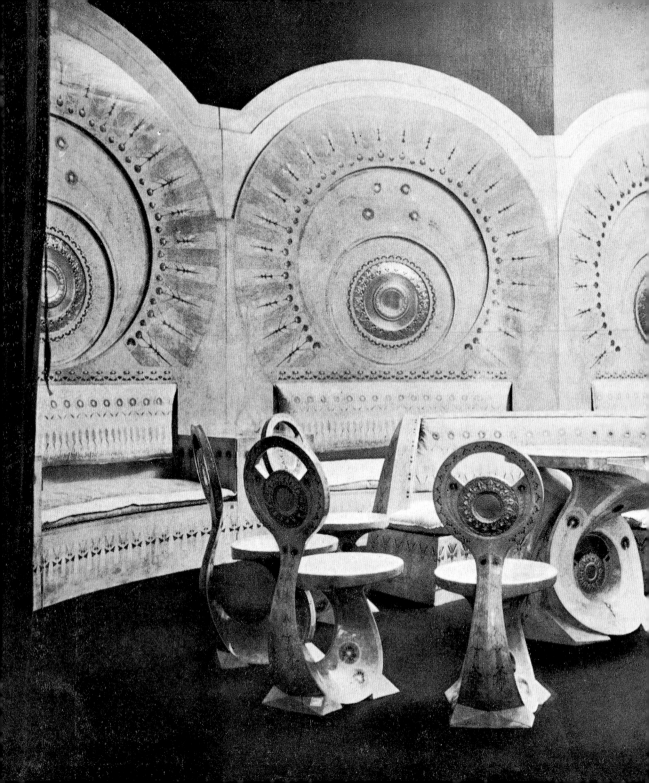

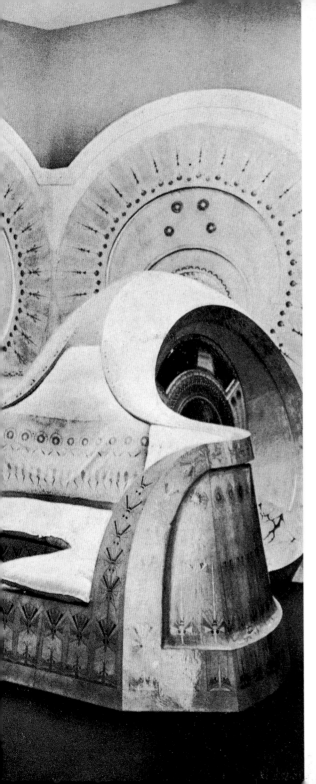

81 C. Bugatti & Co:
room designed for Turin
Exposition 1902.
V&A: NAL.

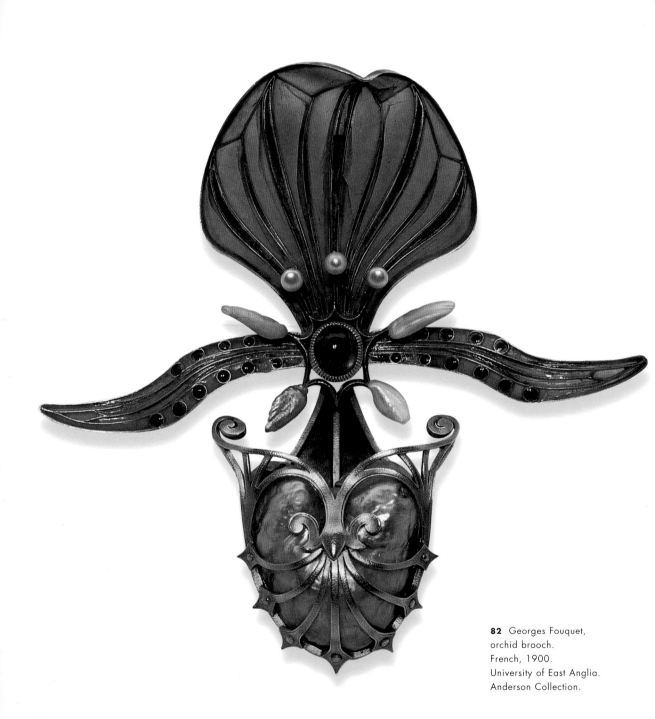

82 Georges Fouquet,
orchid brooch.
French, 1900.
University of East Anglia.
Anderson Collection.

Conclusion

Art Nouveau as a style finally collapsed in the years just preceding the First World War. Its complex use of an eclectic range of sources led to its ultimate demise. Although it heralded many developments in design, it became deeply unfashionable as the new century progressed. The Modernist concern for utility and technology began to dominate *avant-garde* design debates, while public buildings in the post-war years reflected a revived interest in historical styles. Art Nouveau came to be seen as a subversive aberration – or else merely as an insignificant transitionary style.

Elements of Art Nouveau resurfaced in the exoticism of Art Deco or the psychological investigations of the Surrealists, but the style itself did not receive serious attention until the 1960s, by which time many of its major buildings and objects had been lost or destroyed. Today Art Nouveau is recognized as a style that attempted to represent a complex modern environment, where the pace of development not only changed people's experience of the world but also their expectations of what the new century would bring.

	GREAT BRITAIN	FRANCE	BELGIUM AND THE NETHERLANDS	GERMANY	AUSTRIA
1893	LONDON: founding of magazine *The Studio*: Aubrey Beardsley designs published in first issue GLASGOW: Painters George Henry and E.A. Hornel visit Japan 'The Four' meet	PARIS: *Jane Avril at the Jardin de Paris* (Henri de Toulouse-Lautrec) Exhibition of Japanese prints, organised by Siegfried Bing	BRUSSELS: Tassel House (Victor Horta) Founding of magazine *Le Sillon* NETHERLANDS: *The Three Brides* (Jan Toorop)	MUNICH: First Munich Secessionist Exhibition	
1894		PARIS: Castel Béranger (Hector Guimard)	BRUSSELS: Henry van de Velde publishes *Déblaiement d'Art* (reissued 1895). Solvay House (Victor Horta)	MUNICH: Otto Eckmann sells all his paintings to concentrate on design	
1895	LONDON: The first of Oscar Wilde's three trials	PARIS: Siegfried Bing opens his gallery/shop L'Art Nouveau École du Sacré Coeur (Hector Guimard)	UCCLE, NEAR BRUSSELS: Bloemenwerf House (Henry van de Velde)	'Whiplash' embroideries (Hermann Obrist) MUNICH: Richard Riemerschmid designs his first *Maschinenmobel* range ('machine furniture') BERLIN: founding of the magazine *Pan*	
1896	LONDON: Fifth Arts and Crafts Exhibition – the Glasgow Four exhibit for the first time	PARIS: Bing organises graphic art exhibition – Félix Vallotton, József Rippl-Rónai, Georges De Feure and others		MUNICH: Hermann Obrist exhibits 35 embroideries – exhibition travels to Berlin and London Founding of magazines *Die Jugend* and *Simplicissimus*	
1897	GLASGOW: opening of Buchanan Street tearooms (C.R. Macintosh and George Walton)	PARIS: founding of magazine *Art et décoration* The Salon de la Rose+Croix disbands René Lalique's jewellery highly acclaimed, following award at the Salon	BRUSSELS: Van Eetvelde House and Maison du Peuple (Victor Horta) *Exposition Universelle*: designs by Victor Horta, Henry van de Velde, Paul Hankar and Gustave Serrurier-Bovy	MUNICH: Otto Eckmann's *Five Swans* tapestry becomes Art Nouveau icon Elivira Studios (August Endell) DARMSTADT: founding of magazine *Deutsche Kunst und Dekoration*	VIENNA: Founding of the Association of Austrian Artists – Vienna Secession
1898	LONDON: The New Gallery, Regent Street, hosts exhibition of French enamellers (including René Lalique and Georges Fouquet)	PARIS: founding of magazine *L'Art décoratif* Julius Meier-Graefe opens La Maison Moderne	*Tropon* (Henry van de Velde)	MUNICH: founding of the United Workshops for Art in Handicraft DARMSTADT: Founding of the Künstler-Kolonie at Darmstadt	VIENNA: Secession Building (Josef Olbrich) *Pallas Athene* (Gustav Klimt)
1899	LONDON: Archibald Knox designs his Cymric ware for Liberty South Kensington Museum becomes the Victoria and Albert Museum	PARIS: Castel Henriette (Hector Guimard) *Dragonfly Woman* (René Lalique)	THE HAGUE: Rozenburg factory introduces famous 'eggshell' porcelain	STUTTGART: founding of *Der Moderne Stil* BERLIN: Berlin Secession forms *The Kiss* (Peter Behrens)	Josef Hoffmann and Kolomar Moser design for the Loetz glassworks, Klášterský Mlýn
1900	LONDON: Knox designs his Tudric ware for Liberty C.R. Ashbee (furniture and metalwork) and Mackintosh (high-backed chair) admired at Eighth Secession Exhibition, Vienna	PARIS: *Exposition Universelle*. Notable Art Nouveau structures: Loïe Fuller Pavilion (Henri Sauvage) and the Pavillon Bing Opening of Hector Guimard's Metro stations	BRUSSELS: Horta House (Victor Horta) Innovation department store (Victor Horta)	Henry van de Velde moves his office from Brussels to Berlin	VIENNA: founding of magazine *Das Interieur* Eighth Secession Exhibition: contributions from Meier-Graefe's La Maison Moderne, Ashbee's Guild of Handicraft and the Glasgow Four

Nordic Countries	Spain and Italy, Netherlands	Hungary, Czech Republic, Russia	United States	Japan	
NORWAY: *The Scream* (Edvard Munch) Norwegians sail a Viking ship across the Atlantic to the Columbian Worlds Fair, Chicago		PRAGUE: Music Theatre (Friedrich Ohmann)	CHICAGO: Columbian Worlds Fair – Transportation Building (Adler & Sullivan) NEW YORK: Tiffany sets up Corona Glassworks	Japan participates in the Columbian Worlds Fair, Chicago	1893
			BOSTON: Exhibition of Japanese prints, organised by Siegfried Bing		1894
AHVENANMAA ISLANDS, FINLAND: Lasses Villa (Lars Sonck) Finnish designer Akseli Gallen-Kallela visits Berlin		PRAGUE: International Ethnographic Exhibition	CHICAGO: Adler & Sullivan architectural practice disolved. Frank Lloyd Wright builds home and studio; Oak Park Tiffany exhibits at Bing's opening of L'Art Nouveau, Paris		1895
HELSINKI: Herman Gesellius, Armas Lindgren and Eliel Saarinen set up G.L.& S architectural practice OSLO: Fairytale Room, Holmenkollen Tourist Hotel		BUDAPEST: Museum of Applied Arts (Ödön Lechner)	BUFFALO: Guaranty Building (Louis Sullivan) CHICAGO: Louis Sullivan writes *The Tall Office Building Artistically Considered*		1896
CHRISTIANA: founding the Norwegian Weaving Society PORVOO: Founding of Iris project – factory making traditional domestic goods		KLÁŠTERSKÝ MLÝN: the Loetz glassworks launches Phänomen range Poster for 'Job' (Alphonse Mucha)			1897
	TURIN: Exhibition of Italian Decorative Arts. Vittorio Valabrega Co. (furniture firm) exhibits Art Nouveau salon	PRAGUE: Jan Kotěra becomes Professor at the Prague School of Applied Arts	NEW YORK: Tiffany begins to experiment with enamelling	TOKYO: Western-style painting is added to the curriculum of the Tokyo School of Art	1898
HELSINKI: Pohjola Building (G. L. & S.) *The Flame* (Akseli Gallen-Kallela) – rug designed as part of the Iris project		KLÁŠTERSKÝ MLÝN: Radical designs by Marie Kirschner (Czech painter) transform traditions at Loetz glassworks	Tiffany exhibits at the Grafton Gallery, London, and the Paris Salon CHICAGO: Carson Pirie Scott (Schlesinger Meyer) Store (Louis Sullivan)		1899
STOCKHOLM: Association of Friends of Textile Art sell through Bing's L'Art Nouveau HELSINKI: G.L.& S. design Art Nouveau Finnish Pavilion for *Universelle Exposition*, Paris) and Olofsburg Building	BARCELONA: Casa Ametller (Josep Puig i Cadafalch) SORDEVOLO, NEAR TURIN: Vercelloni Villa (Augustino Lauro's Art Nouveau double parlour)	PRAGUE: Peterka House (Jan Kotěra) Jan Kotěra publishes seminal architectural article, *New Art* *La Nature* (Alphonse Mucha)	Tiffany exhibits at the *Exposition Universelle*, Paris	TOKYO: Hayashi Tadamasa made Japanese commissioner for the 1900 *Exposition Universelle* in Paris	1900

CHRONOLOGY

	GREAT BRITAIN	FRANCE	BELGIUM AND THE NETHERLANDS	GERMANY	AUSTRIA
1901	GLASGOW: International Exhibition Glasgow City Art Gallery and Museum opens	NANCY: Founding of École de Nancy – Émile Gallé is first President PARIS: Georges Fouquet opens new shop, designed by Alphonse Mucha		BERLIN: August Endell moves from Munich to Berlin	VIENNA: Josef Hoffmann publishes *Einfache Möbel* (Simple Furniture)
1902	LONDON: Guild of Handicraft moves to the Cotswolds. Josef Hoffman visits Britain's art schools. GLASGOW: The Hill House (C.R. Mackintosh)	PARIS: founding of the *Société du Nouveau*. René Lalique designs his own studio, workshop and showroom		MUNICH: Obrist opens a fine and applied art school with Wilhelm von Debschitz HOHR GRENZHAUSEN: Stoneware factories employ Art Nouveau designers	VIENNA: Josef Hoffmann begins designing simple tab silver
1903	Frederick Carder, English rival to Tiffany's sets up Steuben Glassworks, Corning, New York	René Lalique exhibition at the Grafton Gallery, London			VIENNA: Josef Hoffman and Koloman Moser found the *Vienna Workshops*
1904		PARIS: Bing liquidates his furniture firm		German Section at St Louis Worlds Fair deeply influences American Art Nouveau	
1905		PARIS: La Samaritaine department store (Frantz Jourdain) LIÈGE: *Exposition Universelle* – many official buildings in Art Nouveau	BRUSSELS: *La Parure* jewel casket (Philippe Wolfers) BRUSSELS: Palais Stocklet (Josef Hoffmann)	DRESDEN: Die Brücke group forms	
1906	GLASGOW: Hous'hill (C.R. Mackintosh)		BRUSSELS: Waucquez department store (Victor Horta)		VIENNA: Adolf Loos opens Free School of Architecture
1907				DARMSTADT: Wedding Tower (Josef Olbrich)	
1908	LONDON: Franco-British Exhibition: Largest number of French Art Nouveau objects ever exhibited in Britain				VIENNA: *Ornament and Crime* (article by Adolf Loos)
1909	GLASGOW: final completion of Glasgow School of Art (C.R. Mackintosh)	PARIS: Diaghilev brings the Ballet Russe to Paris			*The Kiss* (Gustav Klimt) *Judith II (Salome)* (Gustav Klimt)

Key moments in the final years of Art Nouveau, leading up to World War I

1910
VIENNA: Vienna Workshops launch fashion department
BARCELONA: Casa Milà (Antoní Gaudí)
VENICE: Venice Biennale includes Klimt

1911
BRUSSELS: Internal refurbishment of Wolfers shops (Victor Horta)
PRAGUE: Municipal House (Osvald Polivka and Antonín Balšánek)

Nordic Countries	Spain and Italy, Netherlands	Hungary, Czech Republic, Russia	United States	Japan	
HELSINKI: National Museum (G.L. & S.) LAKE VITTRÄSK, FINLAND: Vitträsk house (G.L. & S.)		BUDAPEST: Postal Savings Bank (Ödön Lechner) PRAGUE: Hotel Central (Friedrich Ohmann)	NEW YORK: founding of *The Craftsman* COLARADO SPRINGS: Artus Van Briggle sets up pottery C.R. Ashbee visits the States and meets Frank Lloyd Wright.	TOKYO: founding of the Great Japan Design Association and of the Japan Design Group	1901
FINLAND: Arabia Factory launches earthenware range, 'Fennia'	TURIN: *Prima Esposizione d'Arte Decorativa Moderna*. Raimondo d'Aronco wins competition to design the Exposition. Carlo Bugatti wins a first prize for his furniture design	GÖDÖLLÖ: Founding of the Gödöllö Workshops MOSCOW: Riabushinsky Mansion (Fyodor Shekhtel) Remodelling of Moscow Art Theatre (Fyodor Shekhtel)	CHICAGO: Louis Sullivan publishes architectural treatise *Kindergarten Chats* Tiffany Studios open the American Section at the *Prima Esposizione d'Arte Decorativa Moderna*, Turin	KYOTO: the Japan Design Group stages an Art Nouveau exhibition	1902
					1903
HELSINKI: Helsinki Telephone Company (Lars Sonck)	BARCELONA: Casa Battló (Antoní Gaudí)	MOSCOW: Iaroslavl Railway Station (Fyodor Shekhtel)	ST LOUIS: St Louis Worlds Fair	Japan participates in the St Louis Worlds Fair	1904
HELSINKI: G.L.& S disbands Norway becomes independent		PRAGUE: Hotel Europa (Bedřich Bendelmayer and Alois Dryák) MOSCOW: Hotel Metropol (William Walcot, Ilev Kekushev and others)	NEW YORK: Alfred Stieglitz opens the 291 Gallery	TOKYO: Fukushima House (Takeda Goichi), Japan's first Art Nouveau building	1905
	BARCELONA: Casa Milá (Antoní Gaudí)	Hungarian Art Nouveau acclaimed at *Esposizione Internationale*, Milan			1906
Bil-Bol (Akseli Gallen-Kallela)		GÖDÖLLÖ: Sándor Nagy joins the Gödöllö Workshops	NEW YORK: Tiffany moves his jewellery studio to Tiffany & Co.'s headquarters		1907
	BARCELONA: Palau de la Música Catalana (Lluís Domènech i Montaner)	PRAGUE: Founding of the Artel co-operative	CHICAGO: Robie House (Frank Lloyd Wright)		1908
	Revolutionary rising in Catalonia	PRAGUE: Central Railway Station (Josef Fanta) Kotera Villa (Jan Kotěra)	ST LOUIS: founding of the School of Ceramic Art – French ceramicist Taxile Doat is first Director		1909

1912

LONDON: C.R. and Margaret Mackintosh move from Glasgow to London
PRAGUE: Hradec Králové: Municipal Museum (Jan Kotěra)

1913

PRAGUE: Jan Kotěra founds the Union of Czech Artwork
NEW YORK: Woolworth Building (Cass Gilbert)

1914 (WORLD WAR I)

VIENNA: Vienna Workshops go into liquidation
HELSINKI: Central Station (Eliel Saarinen)
BARCELONA: Park Güell completed (Antoní Gaudí)

Picture Credits

Note: Institutions are credited in the captions

Gábor Barka (photo): plate 51.

C.H. Bastin and J. Evrard, Brussels: cover image, plates 2, 35, 45.

Bildarchiv Foto, Marburg: plate 64.

Bridgeman Art Library: plate 14.

Fonds Louis Bonnier: plate 4.

Paul Greenhalgh (photo): plate 37.

Jason McCoy Inc, New York: plate 70.

© Mucha Trust: plate 30.

Lillian Nassau Ltd, New York: plate 69.

Jose A. Navarjo (photo): plate 25.

Wolfgang Pulfer (photo): plates 5, 50.

University of East Anglia. Anderson Collection: plate 82.

Malcolm Varon (photo): plate 24.

Grateful thanks to the V&A Photographic Studio, and especially to Mike Kitcatt.

Further Reading

Arwas, Victor: *Glass, Art Nouveau to Art Deco* (1977, London)

Aubry, Françoise; Vandenbreeden, Jos: *Victor Horta, Art Nouveau to Modernism* (1996, Brussels)

Bakonyi, T.; Kubiszy M.: *Ödön Lechner* (1981, Budapest)

Battersby, Martin: *Art Nouveau* (1969, Hamlyn)

Becker, Vivienne: *The Jewellery of Lalique, Goldsmiths Company* (1987, London)

Becker, Vivienne: *Art Nouveau Jewellery* (1998, London)

Benton, Benton and Sharp: *Form and Function* (1975, OUP)

Berger, Klaus: *Japonisme in Western Painting from Whistler to Matisse* (1992, Cambridge)

Blühm, Andreas and others: *The Colour of Sculpture 1840-1910* (1996, Amsterdam)

Borisova, Elena; Sternin Grigory: *Russian Art Nouveau* (1988, New York)

Borsi, Franco; Wieser, Hans: *Bruxelles, Capitale de l'Art Nouveau* (1971, Brussels)

Bossaglia, Godoli, & Rosci: *Torino 1902: Le Arti Decorative Internaziole del Nuevo Secolo* (1994, Milan)

Bouillon, Jean-Paul: *Art Nouveau 1870-1914* (1985, Geneva)

Boulton-Smith, John: *The Golden Age of Finnish Art* (1985, Helsinki)

Boyer, Patricia Ecker (ed.): *The Nabis and the Parisian Avant-Garde* (1988, New Brunswick and London)

Brunhammer, Yvonne and others: *Art Nouveau Belgium, France* (1976, Houston, Texas)

Brunhammer, Yvonne; Tise, Suzanne: *French Decorative Art, 1900-1942* (1992, Paris)

Brunnhammer, Yvonne: *The Jewels of Lalique* (1998, Paris and New York)

Burke, Bolger; Freedman, Jonathan; Frelinghuysen, Alice: *In Pursuit of Beauty: Americans and the Aesthetic Movement* (1986, New York)

Calloway, Stephen: *Aubrey Beardsley* (1998, London)

Charpentier, Francoise-Therese; Thiebaut, Philippe: *Gallé* (1985, Paris)

Chipp, H.B: *Theories of Modern Art* (1968, UCLA)

Collins, George: *Antonio Gaudi* (1960, New York)

Collins, George; Forinas, Maurice F.: *A bibliography of Antoni Gaudi and catalan movement 1870-1930*, Papers X (1973, Charlottesville)

Conrads, Ulrich: *Programmes and Manifestos on Twentieth Century Architecture* (1964, London)

Crawford, Alan: *Charles Rennie Mackintosh* (1995, London)

Crowley, David: *National Style and Nation State: Design in Poland from the Vernacular Revival to the International Style* (1992, Manchester)

Culot, Maurice; Terlinden, F.: *Antoine Pompe et l'Effort Moderne en Belique 1890-1940* (1969, Brussels)

Cummming, Elizabeth; Kaplan, Wendy: *The Arts and Crafts Movement* (1991, London)

Dierkens-Aubry, Françoise; Vandenbreeden, Jos: *Art Nouveau in Belgium, Architecture and Interior Design* (1991, Belgium)

Dormer, Peter (ed.): *The Culture of Craft* (1997, Manchester)

Dorra, Henri: *Symbolist Art Theories: A Critical Anthology* (1994, UCP)

Duncan, Alastair: *Louis Majorelle: Master of Art Nouveau Design* (1989, New York)

Duncan, Alaistair: *Art Nouveau* (1994, London)

Etlin, Richard: *Modernism in Italian Architecture, 1890-1940* (1991, Cambridge)

Evans, R.J: *Society and Politics in Wilhemine Germany* (1978, New York)

Evett, Elisa: *The Critical Reception of Japanese Art in Late Nineteenth Century Europe* (1982, Michigan)

Findling, John: *Historical Dictionary of Worlds Fairs and Expositions, 1851-1988* (1990, New York)

Findling, John: *Chicago's Great Worlds Fairs* (1994, Manchester)

Fischer Fine Art: *Vienna Turn of the Century Art and Design* (Nov. 1979 – Jan 1980, London)

Fleming, John; Honour, Hugh: *The Penguin Dictionary of Decorative Arts* (1977, London)

Garner, Philippe: *Emile Gallé* (1990, London)

Giedion, Sigfried: *Mechanization Takes Command* (1948, Oxford)

Greenhalgh, Paul (ed.): *Modernism in Design* (1990, London)

Greenhalgh, Paul: *Quotations and Sources on Design and the Decorative Arts (1800-1990)* (1993, Manchester)

Harris, Neil and others: *Grand Illusions: Chicago's Worlds Fair of 1893* (1993, Chicago)

Hayward Gallery, London: *Twilight of the Tsars* (1991, London)

Hiesinger, Kathryn Bloom (ed): *Art Nouveau in Munich* (1988, Philadelphia and Munich)

Holt, Elizabeth Gilmore: *The Expanding World of Art 1874-1902. Volume I: Expositions and State Fine Arts Exhibitions* (1988, New Haven and London)

Howard, Jeremy: *Art Nouveau, International and National Styles in Europe* (1996, Manchester)

Jenkyns, Richard: *Dignity and Decadence: Victorian Art and the Classical Inheritance* (1991, London)

Jullian, Philippe: *The Triumph of Art Nouveau: The Paris Exhibition of 1900* (1974, London)

Kaplan, Wendy: *Designing modernity: the arts of reform and persuasion, 1885-1945* (1995, London)

Koch, Robert: *Louis Tiffany's Art Glass* (1977, New York)

Lamborne, Lionel: *The Aesthetic Movement* (1997, London)

Lenning, Henry: *The Art Nouveau* (1951, The Hague)

Mandell, R.D.: *Paris 1900: The Great World's Fair* (1967, Toronto)

Meier-Graefe, Julius: *Modern Art: Being a Contribution to a New System of Aesthetics* (1908, London, 2 volumes). Translated from German edition (1904, Stuttgart, 3 volumes).

Moorhouse, Jonathan; Carapetian, Michael; Ahtola-Moorhouse, Leena: *Helsinki Jugendstil Architecture 1895-1915* (1987, Helsinki)

Naylor, Gillian: *The Arts and Crafts Movement, a Study of its Sources, Ideals, Influence on Design Theory* (1971, London)

Naylor, Gillian; Brunhammer, Yvonne: *Hector Guimard* (1978, London)

Nerdinger, Winfried: *Richard Riemerschmid vom Jugendstil zum Werkbund* (1982, Munich)

Nöhbauer, Hans F.: *Munich: City of the Arts* (1994, Munich). Translated by Peter Green.

Paris, Musée du Petit Palais – *L'Art 1900 en Hongrie* (1976-77, Paris)

Parry, Linda (ed): *William Morris* (1996, London)

Powell, Nicolas: *The Sacred Spring. The Arts in Vienna 1898-1918* (1974, London)

Rheims, Maurice: *L'Art 1900, ou le style Jules Verne* (1965, Paris), translated as *The Age of Art Nouveau* (1966, London)

Robert-Jones, Philippe (ed.): *Bruxelles Fin-de-Siecle* (1994, Paris)

Russell, Frank (ed.): *Art Nouveau Architecture* (1979, London)

Salmond, Wendy: *Arts and Crafts in Late Imperial Russia: Reviving the Kustar Art Industries (1870-1917)* (1996, Cambridge)

Schmutzler, Robert: *Art Nouveau – Jugendstil* (1962, Stuttgart), translated as *Art Nouveau* (1964, London)

Schorske, Carl: *Fin de Siècle Vienna, Politics and Culture* (1961, London)

Selz, Peter; Constantine, Mildred (eds): *Art Nouveau: Art and Design at the turn of the century* (1959, New York)

Silverman, Debora: *Art Nouveau, in Fin-de-Siecle France: Politics, Psychology and Style* (1989, Berkeley)

Small, Ian: *The Aesthetes* (1975, London)

Solà-Morales, Ignasi de; Gaudí, La Poligrafa, S.A.: *Barcelona* (1983, English edition)

Thiebaut, Philippe: *Guimard* (1992, Paris)

Thurston, Robert W.: *Liberal City, Conservative State: Moscow and Russia's Urban Crisis, 1906-14* (1987, Oxford)

Troy, Nancy: *Modernism and the Decorative Arts: From Art Nouveau to Le Corbusier* (1991, New Haven and London)

Vergo, Peter: *Art in Vienna 1898-1918: Klimt, Kokoschka and their contemporaries* (1994, London)

Verneuil, M.P: *L'Animal dans la Decoration* (1898, Paris)

Weisberg, Gabriel; *Art Nouveau Bing, Paris Style 1900* (1986, New York and Washington)

Weisberg, Gabriel; Menon, Elizabeth: *Art Nouveau: A Research Guide for Design Reform in France, Belgium, England and the United States* (1998, New York)

Wichmann Siegfried: *Japonisme, the Japanese influence on Western Art since 1858* (1981, London)

Williams, Rosalind: *Dream Worlds: Mass Consumption in 19th century France* (1982, Chicago)

Wittlich, P.: *Fin de Siècle Prague* (1992, Paris)

Zukowsky, John (ed.): *Chicago Architecture, 1872-1922* (1987, Munich)

INDEX